'DARE UNCHAPERONED TO GAZE'
A WOMAN'S VIEW OF EDWARDIAN OXFORD

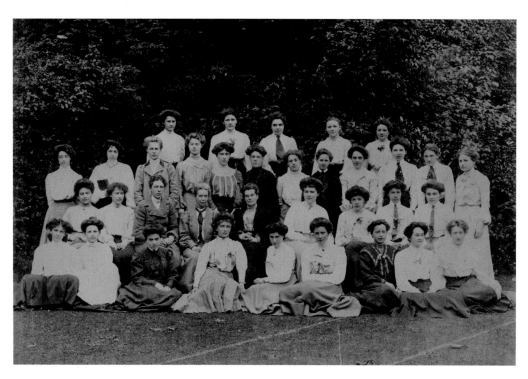

St Hugh's Hall, 1905. Dorothy Hammonds is probably second on the left in the second row from the back. No identifiable photograph of Margaret Mowll survives, so it is impossible to suggest who she might be.

'Dare unchaperoned to gaze'

A Woman's View
of Edwardian Oxford

Edited by
George Garnett

Transcribed by
Debbie Quare, Nora Khayi,
and Amanda Ingram

ST HUGH'S COLLEGE
OXFORD

ISBN 978-0-9933235-0-8

British Library Cataloguing in Publication Data
A catalogue record for this book is available
from the British Library

Published by St Hugh's College, Oxford
Designed by Stephen Hebron
Typeset in Monotype Bulmer
Printed in Malta by Gutenberg Press

CONTENTS

ACKNOWLEDGEMENTS

We are grateful to Neill Coleman, a St Hugh's historian, and his employer, the Rockefeller Foundation, for generous benefactions which made this publication possible.

Debbie Quare, sometime Librarian of the College, produced the original transcript, which has been revised by Nora Khayi, her successor, and Amanda Ingram, the College Archivist. Declan McCarthy, Commercial Services Manager of the Ashmolean Museum, gave essential advice in the early stages, arranged for the Museum's Photographer, David Gowers, to produce the facsimile, and dealt with all the technical aspects of production. Stephen Hebron, Curator in Special Collections at the Bodleian Library, undertook the design. Millan Sachania, Headmaster of Clapham and Streatham High School, and Christine Belsham, the School Archivist, provided crucial evidence which would not otherwise have come to light. The many specialists whose expertise has been drawn upon in the Introduction are thanked in the footnotes thereto.

Above all, we must acknowledge the wisdom of Dorothy Hammonds' godson and executor, Richard Whalley, for appreciating the Diary's significance and donating it to the College in 1975.

All proceeds from sales of this book will be allocated to the College Library, which still contains some of the books consulted by Dorothy Hammonds and Margaret Mowll when they were communing with 'the Muses'.

St Hugh's College,
Oxford

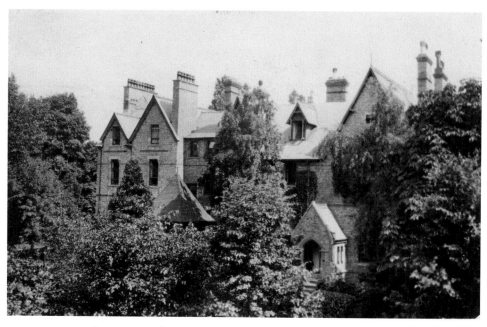

Contemporary photograph of 17 Norham Gardens, the main building of
St Hugh's Hall when Dorothy and Margaret were in residence, taken from the front.

FOREWORD

History books and official records offer important insights into the story and character of any institution, though the former are usually written at considerable chronological distance from the events (and with at least a pretence at objectivity), and the latter's austerity can obscure the everyday trials and tribulations of its inhabitants. As such, both types of work may sometimes lack a strong sense of what it felt like to be there. By contrast, personal narratives add colour, warmth, and depth. They bring the institution to life through the intimate descriptions of the characters set out in their pages.

This diary of the lives of Dorothy Hammonds and Margaret Mowll, as students at St Hugh's Hall (as it then was), brings to life a host of Oxford characters through contemporary, close, and often humorous observation. The Diary opens a door into the St Hugh's (and Oxford) of 1905, many years before its students were permitted to vote or to take degrees, regardless of their abilities or their academic endeavours. While the Diary's entries are intriguing, the accompanying sketches and watercolours transform the Diary into a precious memento of such a formative time in the diarists' lives and in the life of St Hugh's.

These casual observations of daily life at St Hugh's are eloquent evidence that the intelligence, wit, and enthusiasm of the student body of 2015 has a strong foundation in the student body of 1905. In the intervening years much has changed at St Hugh's, but the passion for learning and for amusement remains constant. I would have been delighted to have known these lively and intelligent women, just as I am privileged to spend time with the brilliant men and women who study here today.

George Garnett, Tutorial Fellow in History at St Hugh's, has written an immensely engaging and affectionate introduction to the Diary. His discussion provides vital historical and social context, refining our understanding of the Oxford in which Dorothy and Margaret lived and studied. I am grateful to him for this historical perspective and for his enthusiasm and energy in seeing this project through to its publication.

I am also very grateful to Nora Khayi, the College Librarian, and to Amanda Ingram, the College Archivist, for their tremendous support to the project and

for their research in the production of this book. Many thanks are also due to Neill Coleman, St Hugh's alumnus (1993, Modern History), for his generous financial support for the publication of this book, and to his employer, the Rockefeller Foundation, for matching his benefaction.

Elish Angiolini

Principal of St Hugh's College
March 2015

INTRODUCTION

I̶N̶ O̶C̶T̶O̶B̶E̶R̶ 1904 Dorothy Hammonds[1] and Margaret Mowll were the first pupils from Clapham High School to be admitted as students at St Hugh's Hall, Oxford, as it was then known.[2] The Hall was less than twenty years old, having been founded in 1886, the third residential Hall established for women in Oxford.[3] In a letter which Dorothy[4] wrote to the school at the end of her first year she gives an evocative, elegantly turned account of her first impressions of 'all the wonderful power that Oxford possesses – that silent influence which is ever at work, and which seems to emanate from an appreciation of the historic beauty of the city, and the thrilling interest of its traditions.'[5] The tone is more reverential than that of the Diary which she and her room-mate Margaret began to keep at the start of their second year, and for which they took joint responsibility, but of which Dorothy appears to have been the primary author.[6] Perhaps she adopted this tone because she knew that the letter would be published in her school magazine, and was all too aware of the likely reaction of her redoubtable headmistress, Mrs Woodhouse, to any levity; but the Diary, in its playfully arch fashion, provides still more authentic confirmation of the transformative delight she took in being educated here.

The evidence for the early history of St Hugh's is fairly sparse, and almost all of it is official.[7] There are also reminiscences written long afterwards by Old Students, but the Diary is by far the most substantial document to evoke with immediacy the experience of student life in St Hugh's in the period prior to the First World War. That immediacy, the informality of the style in which it is expressed, and the evident excitement of its authors, all contribute to a frequently telegraphic allusiveness which requires some setting of context to help the modern reader to grasp the Diary's meaning. What, then, was the character of the institution which was the main stage for the events chronicled in the Diary?

The Hall had been founded by the first Principal of Lady Margaret Hall, Elizabeth Wordsworth. Miss Wordsworth had had a very specific purpose in mind. The new adjunct to Lady Margaret Hall, initially comprising just four students in a rented house (25 Norham Road), was to provide a university education for women whose parents could not afford the fees at the other Oxford women's Halls, and who were also concerned that their daughters should not

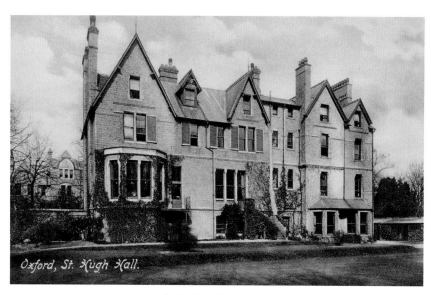

Postcard of 17 Norham Gardens, from the back

be obliged to attend economical but '"unsectarian" places of instruction',[8] by which she must have meant the new godless institutions of London, Manchester, and elsewhere, and perhaps the non-denominational Somerville Hall in Oxford. Miss Wordsworth saw clerical fathers, almost always strapped for cash, as her primary clientele: St Hugh's was to be a poor girls' Lady Margaret Hall. Herself the daughter of a bishop of Lincoln, she chose to name the new institution after the only canonised bishop of Lincoln, Hugh of Avalon, in whose day the large diocese had encompassed Oxford. St Hugh's alleged 'reverence for women was all the more remarkable from the fact that he belonged to the ascetic Carthusian order,'[9] and was, to her mind, a further justification for naming the Hall after him. As first custodian – from the start termed Principal – of the new institution, she appointed the daughter of a bishop of Salisbury, Miss C.A.E. ('Annie') Moberly, as a woman not only capable of delivering Anglican instruction to her charges, but also of being 'an economical housekeeper'.[10] Miss Moberly was, therefore, intended to be a living embodiment of Miss Wordsworth's two founding imperatives: godliness and parsimony.[11]

When Dorothy and Margaret arrived in 1904 Miss Moberly was still Principal – she remained so until 1915 – but much else had changed. The offer of down-market Anglican education had proved attractive from the very start: when Dorothy and Margaret came into residence in Michaelmas Term 1904

there were 31 students. To accommodate the rapidly expanding numbers Miss Wordsworth had, in 1888, bought the leasehold of a new 'desirable and commodious'[12] house, 17 Norham Gardens.[13] This was conveniently next-door-but-two to Lady Margaret Hall; and not long after, in 1894, she attempted to amalgamate St Hugh's with Lady Margaret Hall, as a hostel for those of modest means which would henceforth be formally attached to the grander parent institution. In this plan, however, she was thwarted by her colleagues on the governing Council of Lady Margaret Hall, for a recorded reason which reveals a great deal about social anxieties in late Victorian Oxford: the Council took the view that amalgamation would mean that 'the tone and average standard would not be quite so select and high'.[14] Far from being effortless, Lady Margaret Hall's social superiority could be maintained only with unflinching vigilance. Even at arm's length, the impecunious might threaten to tarnish the carefully cultivated image. It may have been this insecurity which led to the Principal of Lady Margaret Hall's being officially entitled 'Lady Principal', an emphasis not accorded to the Principal of St Hugh's.

Shortly after the decision not to amalgamate, St Hugh's ceased to be in any sense an institutional adjunct of Lady Margaret Hall, though remaining for another twenty years its geographical neighbour. In 1895 a private Trust Deed established it as a distinct entity, with its own governing Council consisting mostly of external members, of whom Miss Wordsworth was simply one amongst roughly seventeen (the numbers fluctuated), not its chairman.[15] Three years earlier a new wing had been added to 17 Norham Gardens, with student rooms, a 'dining hall' with a dance floor, and a chapel,[16] the décor of which Miss Moberly reverently described in minute detail;[17] in 1901 further accommodation was acquired at 28 Norham Gardens, a house so close by (fussed a St Hugh's *Report*) that 'no inconvenience has been felt in passing from one house to another for meals.'[18] Most bedrooms 'divided by screens' were expected to be shared by two occupants,[19] otherwise a substantial supplement was payable.[20] From the beginning of the new century annual *Reports* became increasingly insistent about the cramped conditions in the chapel, built less than a decade before.[21] High-minded privation was one thing – over half a century later one Old Student could still recall with disgusted vividness the sort of food she had been obliged to eat[22] – but the Hall's success in attracting students must not be allowed to have the unintended consequence of compromising their devotions. This was the burgeoning, austere, impoverished, and ostensibly devout – or at least religiously dutiful – community into which Dorothy and Margaret entered in October 1904.

If St Hugh's was peripheral by comparison with the self-conscious gran-
deur of Lady Margaret Hall, all women students in Edwardian Oxford were
peripheral to the University. They were termed students because, as women,
they could not be members of the University, and therefore undergraduates.
Unlike in the new universities at London, Manchester, and elsewhere, women
were not admitted to Oxford degrees, so could not graduate. The same was and
remained true at Cambridge until 1948. In response to considerable demand,
in 1875 the University had instituted separate examinations for women, which,
if the subjects were available to men – at that time there were no Honours exam-
inations in English or Modern Languages – were officially declared to be of
the same standard.[23] But for decades the University took no responsibility for
the prior activities of the women students who presented themselves for these
examinations. To fill the vacuum, in 1878 an Association for Promoting the
Higher Education of Women in Oxford (soon familiarly termed the A.E.W.)
was founded, and a year later Lady Margaret Hall and Somerville Hall were
opened.[24] The Halls were at first precisely that, halls of residence; it was the
A.E.W. which initially took sole responsibility for the tuition of students,
arranging tutorials, providing chaperones for those attending University and
College lectures (a requirement eventually lifted in 1911),[25] a service charged
at the discouragingly expensive rate of one shilling an hour in the 1890s (1s 6d
an hour by 1914),[26] and so forth. In 1884 the A.E.W. succeeded in persuading
the University to open some of the existing Honours examinations to women;
thereafter women's examinations survived only in subjects which were not
(yet) available as Honour Schools[27] – most popularly, English Language and
Literature, and Modern Languages. Over the ensuing decade the number of
subjects in which there were common examinations for (male) undergraduates
and (female) students was expanded to encompass almost all subjects offered
by the University (other than Medicine, which remained closed to women until
1917). In 1896 a serious attempt was made to persuade the University to admit
women to the B.A. degree, but it failed.[28] By the time Dorothy and Margaret
came up in 1904, the last women-only Honour examination had just been held,
in Modern Languages;[29] but the existing arguments deployed against women's
admission to the B.A. degree had recently been sharpened by the increasingly
energetic campaign for women's suffrage. Unless women B.A.s could somehow
be barred from qualifying for the subsequent M.A., they would in due course
become members of Convocation, entitled to vote on matters of University gov-
ernment, and, more pertinently, in the election of its Members of Parliament.
Their admission to degrees could therefore be presented as quite incompatible

with their continued exclusion from the parliamentary franchise;[30] and it is striking that admission to degrees was eventually conceded only shortly after (most) women were enfranchised in 1918. So Dorothy Hammonds was admitted to St Hugh's to read for the fairly new Honour School of English Literature, established in 1894;[31] but although her performance in Schools would (like that of male candidates) be classified, she had no prospect of receiving an Oxford degree. After 1895 this was true of only two other universities in the British Isles; and in the year she came up, Trinity College, Dublin began admitting women to degrees.

This account of the character of St Hugh's Hall, and of the position of women students in Edwardian Oxford, might suggest that an intelligent and spirited eighteen year old would have found the experience of being a student here oppressive, indeed that she could easily have come to loathe the place. The letter which Dorothy wrote to her school at the end of her first year, and the Diary which she and her room-mate began to keep at the beginning of their second year, demonstrate that nothing could have been further from the case. As 'R', the author[32] of the 'Foreword' states, the Diary's text is 'full of subtle humour, of delicate unhurtful wit', though her further suggestion that 'a true vein of earnest piety runs through the whole' seems as tongue-in-cheek as the Diary itself. Pious the authors may have been, but earnest they most definitely were not. Such was not the Anglican way. Nor do they appear downtrodden, but effervescent – 'fearfully bucked'[33] – and more than a little mischievous. In Edwardian Britain the opportunities for young, middle-class women to get away from the parental home without enterprising matrimony were few. The authors give every impression that they and their peers grasped this one with considerable relish.

The Diary's most remarkable feature is not its text, but the sketches which complement so many entries, and which enable us to see Edwardian Oxford through Dorothy's eyes, for she alone was responsible for them.[34] In 1901, while still at school, she had been awarded the 'Council's Honour Drawing Certificate, Division V'.[35] Division V is probably a category rather than a grade, but if this was a poor mark, either the examiners did not esteem delightful and witty sketches, or her drawing had improved dramatically over the intervening four years. In juxtaposition with the wry and occasionally arch captions and observations in the Diary's text, these sketches give a very clear impression of how much fun the two friends had not only in their studies – referred to as communing with 'the Muses' – but still more so in taking pleasure in the foibles of the other members of St Hugh's, and of the University at large.

Although the A.E.W. had initially taken responsibility for the tuition of women, St Hugh's, like the other women's Societies, began to have what the Diary terms (in conventional Oxford parlance) 'Dons' from a very early stage. The first Vice-Principal was appointed in 1889. By the time Dorothy and Margaret came up, there had been no fewer than eight, a fact which was later attributed to the Principal's difficult personality: 'She did not find it easy to discover one who would work under her for long.'[36] The precise nature of the office in the early years is unclear; perhaps to supply the formal academic qualification which the Principal lacked. The Vice-Principal in post in 1904, Eleanor Jourdain,[37] a 'Doctor of the University of Paris' no less,[38] was later listed in a Hall *Report* as also an A.E.W. Tutor in French.[39] A predecessor, Dora Wylie, on appointment (1898) simultaneously became 'resident Tutor' in History;[40] after her departure in 1900, she was soon replaced (1902) in the latter capacity by Lettice Fisher, who cannot, however, have been resident, because she was married to a History Tutor of New College. Of more immediate relevance to Dorothy Hammonds – though curiously never mentioned in the Diary, unlike Mrs Fisher – must have been Edith Wardale, titled Miss despite holding a Ph.D. of the University of Zürich, an Old Member who had formerly been Vice-Principal (1889–1894) and had sat on the governing Council since its institution in 1895.[41] In 1901 she was appointed to preside over the newly acquired 28 Norham Gardens,[42] and although she had relinquished this position by 1904, she was then said to be staying on as 'English Tutor'.[43] This was a subject which she had taught for the A.E.W. for many years. It is not clear to what extent these Tutors were simply A.E.W. Tutors who (in cases other than Lettice Fisher) happened to have agreed to reside in one of the St Hugh's houses, and to what extent they were considered office-holders of St Hugh's.[44] Probably such a precise distinction is anachronistic. Annie Rogers was not listed as a Tutor of St Hugh's until the 1908 *Report*, but she had long been an A.E.W. Tutor in Classics, and had also sat on the St Hugh's governing Council since 1895. Although neither Dorothy nor Margaret appear to have been tutored by her,[45] she occasionally looms in the Diary, as an active presence in the Hall. These are the Diary's Donnish *dramatis personae*. The Principal is strikingly absent, despite the small size of the intimate community over which she formally presided.[46] By this point she seems to have become a rather remote figure. A visit by the wife of the Master of Balliol – 'Mrs Balliol' – is mentioned, and even illustrated, but not Miss Moberly.[47] The Diary makes no comment on her compulsory Sunday evening Bible classes, which Dorothy and Margaret must have attended.[48] Very few of the Diary's entries were written on Sundays.

However forbidding one might expect some of the 'Dons' to have been, these particular students were evidently not intimidated, though they might regard dinner with the 'Dons' as something an ordeal,[49] and not just because the food was often unappetising.[50] Annie Rogers is characterised as 'the Vampire of the A.E.W. The fell Tyrant of the classical students. The bully of all beginners. She is a woman (?) who has brutality but not wit, force but no humour (she has a nose).'[51] There was alarm when it was briefly suspected that 'the V.P.' might have overheard them 'loudly denouncing & ridiculing' her.[52] 'The V P. has such excellent ears!' But Miss Jourdain seems to have had that ability so desirable in one acting *in loco parentis* of knowing when to bend the rules. One evening the authors had tickets for a Union Society debate, but could find no chaperone, and feared that they would therefore miss it. 'However, E J arrives with welcome news that we may dare "unchaperoned to gaze" upon the members of the School for British Statesmen.'[53] On another occasion Dorothy had attended a Smoking Concert at St John's College: 'It doesn't sound respectable, but the V.P cast a cloak of propriety over "the proceedings" or rather over our presence there.'[54] On this occasion Miss Jourdain had done so by accompanying her pupils: they had listened to 'a comic, not to say Music Hall song, illustrated by a fandango and accompanied by some excellent whistling. The VP is as pleased as punch and roars with laughter. DMH fancies she hasn't caught the words.' More likely, the Vice-Principal knew when to turn a blind eye or a deaf ear, and had a sense of fun;[55] though her willingness selectively to waive the rules on chaperones was susceptible to a less flattering interpretation.[56] These episodes suggest that protective fussiness was not always the order of the day, despite the reassurance constantly being offered to parents of prospective students in the *Report*, which appears to have functioned as something akin to a prospectus as well as an annual public record.[57] It is interesting to note that the Diary gives no sense that the very peculiar and subsequently celebrated psychical experience which the Principal and Vice-Principal had shared shortly beforehand, in 1901, had made any impression on these particular students. Perhaps they were not amongst the favoured few in whom Miss Jourdain confided about what she and the Principal were convinced they had seen in the grounds of Versailles.[58]

The 'little pencil-wielder'[59] occasionally offered pen portraits of her peers,[60] but her fellow students are so intrinsic to the events of each day that they appear more often as the subjects of sketches than of verbal character assessments, though according to the author of the Foreword the subjects would not be able justly to accuse her of caricature. That 'R' felt obliged to reject the charge

suggests that it might plausibly have been made. Only rarely, and then most often with new arrivals, is Dorothy catty about the physical appearance of her peers: a 'lengthy toilette of an hour and a half did not produce a worthy result. Plain, prim and pink.'[61] Undergraduates, by contrast, are 'inspected closely':[62] when T.G.R. Dehn of Balliol grew what appears to have been a very slim moustache, an updated portrait was juxtaposed with one of him clean-shaven.[63] In many instances they were pilloried mercilessly, as is at least one young male Tutor.[64] Indeed almost every day's entry, after a brief account of last minute arrival at a more often than not disappointing breakfast, has a section entitled 'Varsity News' which is primarily concerned with those termed 'boys' by a 'Russian Princess', to the great amusement of the authors, and the corresponding chagrin of 'the Varsity'.[65] Some were obviously the object of considerable interest, most especially the Hon. Henry Lygon of Magdalen, christened by them 'the Pride of All the Beauchamps', with whom both of them seem to have become more than a little obsessed.[66] He was the fourth son of the sixth Earl Beauchamp, and therefore the younger brother of the current Earl, who would later, reputedly, be Evelyn Waugh's model for Lord Marchmain in *Brideshead Revisited*.[67] To judge from the Diary's sketches of Henry, there was more than a touch of Sebastian Flyte about him, and probably more than a touch of Charles Ryder about Dorothy's interest in him. Certainly he is made to conform to an idealised stereotype.

Passing encounters with other undergraduates might occur by accident[68] or design, or be deliberately avoided,[69] but they were meticulously noted,[70] and often illustrated.[71] Queen's Lane seems to have been a favoured hunting ground, perhaps because that was their route to the Examination School for lectures.[72] Mysterious males were appraised when they appeared unexpectedly.[73] The authors kept their eyes peeled.[74] One female conquest, of a man named Dixon, is reported, and the starry-eyed conqueror depicted as apparently no less 'smitten' than her victim.[75] More formal social engagements, such as attending a concert or a play, required the attendance of a chaperone;[76] so did watching the rowing during Eights week, though, curiously, not rowing by oneself on the Cherwell[77] – for that, one needed only to pass a swimming test.[78] But sometimes when a chaperone had been booked she simply failed to turn up,[79] or was 'culled'.[80] Whereas most fellow members of St Hugh's are referred to by their initials, most undergraduates are given nicknames. One may rejoice in no fewer than four, and certainly has three.[81] Most male nicknames – 'the Rat'[82]; 'the Earwig';[83] 'the Debauchee;'[84] 'the Fish'[85]– cannot have been intended to be flattering. Lord Hugh Cecil, MP for Hereford and a speaker at

a Union debate, is even characterised as 'the missing link'.[86] By contrast, 'the "Bass by the window"' at a lecture in the Examination Schools 'returns from football looking hopelessly nice', and is so depicted.[87] The lecture which he had left the pitch to listen to was, however, also attended by a very different sort of 'undergrad, ugly but funny', who, before the lecture began, asked a caretaker to move the blackboard so that he could see better, and the female members of the audience not at all: 'huge delight of undergrad, who giggles continuously during the lecture.' Dorothy's revenge is wreaked in her picture of him, and its caption: 'Envy, hatred and malice and all uncharitableness'.[88] Another comical lecture room incident is provided by 'the-only-man-in-Balliol-worth-knowing' realising that he had been upstaged by a mere 'girl' in competition to impress a lecturer with the acuity of their respective questions.[89] These students were certainly not in awe of the intellectual calibre of the undergraduates – indeed, in many instances rather the opposite: 'M.K.M. learns that a man at Hertford has been rewarded by his father with a motor car' for passing Responsions, the elementary examination which was a pre-requisite for embarking on the degree course. 'The Varsity is trying to resolve the problem as to his scale of rewards for Mods and Finals.'[90]

But encounters with undergraduate members of the University, or 'Varsity', were not confined to mild flirtation or its opposite, to chaperoned smoking concerts, plays, parties, lunches, and teas. Students did not attend the Union just to 'gaze' chaperoned at the undergraduate (and other) speakers[91] – although it is clear that it was not just, or even mainly, the oratorical flair of 'the Pride of All the Beauchamps' which most impressed them about him. It is chastening to realize just how politically well-informed these students were, in a period of exceptional eventfulness in British politics.[92] They would put most modern undergraduates to shame. The new Liberal Ministry's Education Bill of April 1906 was even more controversial than most Education Bills were in Victorian and Edwardian Britain; it became a political *cause célèbre*. It was seen as, and indeed was, an attack on the Established Church, because it ordained that all aided denominational schools should be taken over by local authorities, and because it restricted religious education in schools. The Government was playing to its Nonconformist constituency. The Bill therefore undermined one of the founding principles of St Hugh's, as the many daughters of Anglican clergymen who studied there could not fail to have been aware. Dorothy's father, a clergyman who was also the Principal of an Anglican teacher train-ing college, was himself heavily involved in the resistance.[93] The *St Hugh's Club Paper* for 1905–1906 reports that 'Everyone came up [at the beginning

of Trinity Term] with the Education Bill in her pocket.'[94] There were both ardent advocates for and opponents of women's suffrage in St Hugh's,[95] but no-one seems to have had a good word to say for the Government's Education Bill, which remained for many months a subject for 'animated discussion'.[96] On Thursday 26 April 1906 the Union staged what the Diary describes as 'a splendid Debate' on the subject, 'especially from the episcopal point of view' – the first debate held under the Presidency of 'the Pride of All the Beauchamps'. Dorothy and Margaret declared his demeanour on that occasion to have been exemplary.[97] In his capacity as President, Lygon chaired the debate and did not speak either for or against the motion; but it was an irony unremarked in the Diary that his elder brother, the seventh Earl Beauchamp, was at the time Captain of the Honourable Corps of Gentlemen-at-Arms, an honorary position held by the Government Chief Whip in the House of Lords.[98] He was the unfortunate who had the job of ensuring that the Bill got though the House. His inability to pull off this well-nigh impossible feat represented the first act in the constitutional drama which would eventually culminate in the celebrated confrontation of 1911.

A large public protest meeting in Oxford Town Hall the week after the Union debate attracted 'nearly all the Hall';[99] at it, Henry Lygon expressed views similar to those of 'the Junior Common Room' (and therefore contrary to those of his elder brother). It was unusual but perhaps not in this case surprising for these particular female critics of male oratory to be so positive in their appraisals of both the Union debate and the subsequent public meeting – it is clear where their political sympathies lay on this issue. In general, they were much less impressed by male speakers. For instance, they were scathing about the Union debate held on the evening when the Vice-Principal had exempted them from the requirement to take a chaperone: 'If the Speakers of tonight are England's Embryo statesmen, the prospects of the country are indeed small. We feel we must refer to the Magdalen gentleman who spoke fourth. His politics were fanciful & savoured of the nursery, his style easy & boyish, not to say infantile. He offered the country some good advice, & assured an incredulous & smiling House that his remarks were quite true.'[100] Had that other Magdalen man, 'the Pride of All the Beauchamps', been speaking on this occasion, doubtless it would have been another story.

Membership of the University was a necessary but not a sufficient condition for admission to membership of the Union, and women were of course not members of the University.[101] But they had established alternative *fora* where they could develop their rhetorical arts. The grandest and most formal was the

Oxford Students' Debating Society,[102] encompassing all the women's Societies, of which Margaret was elected Treasurer for Hilary (then called Lent) Term 1906, and President for Trinity (then Summer) Term.[103] The Diary acknowledged that there were 'essential differences between male & female debating capacities and gifts of oratory',[104] but in such a way as to imply that the comparison was almost wholly to the detriment of the males, the exception being 'the Pride of All the Beauchamps'. When Margaret made her first speech to the O.S.D.S., Dorothy applauded 'as "lygonistically" as possible, both hand and foot.'[105] Margaret had on that occasion been opposing a motion for the extension of the system of co-education in England, and had done so with some brio: she observed of the system's products that 'the girls were unwomanly and rough, and the boys were mere freaks.'[106] Lygon was, naturally, a product of that single-sex school, Eton College. If the reminiscences of a (male) contemporary are to be trusted, Dorothy's and Margaret's estimate of his abilities almost matched his own: 'when he was elected President of the Union … nobody could have convinced poor Henry that he would not one day be Prime Minister.'[107] Only one debate on a political subject – the Education Bill yet again – is recorded in the Diary as taking place under the aegis of the O.S.D.S., the first over which Margaret presided:[108] 'Public discussion was characterised by unusual fervour, and more than the customary number of speeches.'[109] So many of the St Hugh's students were so interested in politics that a St Hugh's Parliament was established, first meeting on 4 December 1905. 'We were greatly aided in this by the remarkable familiarity displayed by some of our members, not only with the temperaments of His Majesty's ministers, but also of the intricacies of procedure in the Imperial Congress.'[110] Margaret filled the role of Unionist (i.e. Conservative) Home Secretary (elsewhere she is said to speak in a 'Unionistie' style – 'what higher praise can man or woman seek?'; it was also observed of her that she could 'talk of nothing else but' politics),[111] and Dorothy, with a studied unconventionality which may have been characteristic, the Labour Member for Battersea. She asked questions of the President of the Board of Education, and Margaret introduced an Aliens Bill.[112] 'Parliament "sits" in the Common Room in No. 28 [Norham Gardens]. And very imposing the Common Room looks arranged on strictly Westminsterian lines!'[113] In addition to 'Protection' and 'the Channel Tunnel Scheme', at some unspecified point in 1906–07 the Parliament debated women's suffrage, 'the most stirring [debate] we have had'. The speakers were Old Students,[114] and there is no indication either in the *Club Paper* or in the Diary of the positions adopted on this issue by the Home Secretary and the Member for Battersea.

The Vice-Principal, no less, was in the vanguard of this cause, though not in the forum of the students' Parliament. She and Edith Wardale would soon take part in the 'great demonstration' of 13 June 1908 in London, both apparently wearing their doctoral gowns;[115] but it seems that the student body was by no means unanimously of the same progressive opinion. The Diary mentions the public meeting held in New College Hall on 11 November 1905 on 'the Assyrian Mission', at which 'the only object of interest was Dr Sp[oone]r who however ejaculated no [Spooner]isms!' There is no mention of another public meeting which took place in the same year, on women's suffrage.[116] The *Club Paper* reports, with what seems to be a hint of subversive regret, that by 1907 'the Conservative majority [in Hall] is rather overwhelming'[117] – perhaps a lingering consequence of the way in which St Hugh's had, in 1906, aligned itself *en masse* with the Established Church, the Tory Opposition, and Mr Balfour's poodle in their collective destruction of the Government's Education Bill. When Cecilia Ady had spoken against a motion of no confidence in His Majesty's Government at the O.S.D.S. on 27 February 1906, it was observed that 'it is doubtful whether a Demosthenes' could have prevailed because 'the House invariably maintains its *a priori* conservative leanings.'[118] But the Diary reveals that formal political debate within the Hall also took place in more impromptu *fora* than the Parliament: in the 'Society for the Propagation of Cheap Repartee',[119] in the 'H.T.S.',[120] and at 'Sharp Practice'.[121]

Political awareness and interest was not, therefore, necessarily synonymous with political engagement. There was much more in which to take pleasure in Oxford than encounters with undergraduates and debating, important though both these activities were. There were 'the Muses', who might, on occasion, require arduous and sustained application – in Dorothy's case, to the 'unpalatable' rigours of philology[122] (English in its infancy being still a rigorous School). She and Mary Cornish are the authors of an amusing piece of doggerel entitled 'Philology for the Feeble-Minded (By Two of Them)'.[123] But while it was easy to amuse with tales of lectures and lecturers[124] – 'No lectures so no humour'[125] – it would have been very difficult to make accounts of study entertaining: 'This was the day we slogged.'[126] There was drama: the Shakespeare Society[127] for instance; but it may be no accident that the fullest account of participating in a production – of 'She Stoops to Conquer' – is chiefly concerned with lamenting the undesirability of the few male members of the audience: 'They admitted none of the male sex, <u>except</u>, and this seems to us drawing a rather nice distinction, except those who have reached the supreme position of <u>grandfather</u>.'[128] There was sport: hockey against St Hilda's[129] and unspecified opponents,[130]

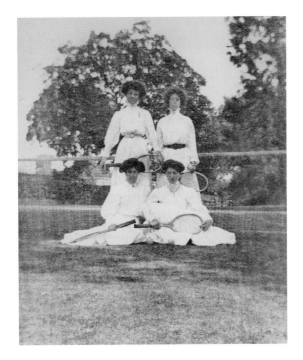

Notes on the reverse of both photographs, made long after they were
taken, suggest that they depict Dorothy Hammonds. In the lower
photograph, she is putatively identified as the seated figure on the left.

even against the house-maids (a veil is drawn over the result);[131] rowing;[132] and for Dorothy above all tennis,[133] at which she excelled. Hence, presumably, her decision to depict herself in tennis gear in her pastel self-portrait.[134] There were 'Sociables'[135] – jolly gatherings within the Hall. There were charades, at which the Dons were often mimicked.[136] And there were the shared sufferings and comic potential of communal life: the dreadful food,[137] the cold,[138] which might be ameliorated at the cost of a visit from the 'leery Stephens' – 'The Herald of the Morn', who seems to have enjoyed attending on the young ladies just a little too much – delivering coal[139] (there was an extra charge for a fire);[140] and the 'conflagration' caused by the Russian princess.[141] Even 'pictures on S.H.H. walls never hang straight.'[142]

What there was most definitely not, was any sense of the earnest Anglican devotion which the Foundress and the Principal doubtless expected, and which successive annual *Reports* attempt to present as the Hall's *raison d'être*. Opposition to the Education Bill, which constituted a threat to the institutional power of the Established Church, was one thing; religious enthusiasm – or earnestness – would have been quite another. Cardinal Newman might still be a name to conjure with, especially in Oxford;[143] but the closest the Diary comes to mentioning the Hall's chapel, about which the terse *Reports* wax so uncharacteristically eloquent, is the passing observation that sausages for breakfast on Wednesdays had in the previous year served 'as compensation for the Litany',[144] presumably at Matins. On Sunday 21 January 1906 the friends attended Evensong in Christ Church Cathedral, but they recorded this solely because it helped to explain a chance encounter in the dark, on their way back to Norham Gardens, with some men.[145] Another visit to the Cathedral, when they also took in St Peter's-in-the-East (now deconsecrated, and converted into St Edmund Hall library), was evidently for reasons of architectural interest, not devotion.[146] The nature of the 'clerical infatuation' which prompted Gertrude Seely to cycle to a service in Keble Chapel ten minutes before it started, even though it was a mere five minutes' walk away, is left hanging in the air; but it seems unlikely that she was so keen to arrive early in order to kneel in preparatory prayer.[147] There is no indication that these students felt greatly restricted or oppressed by the religiosity of St Hugh's, or more generally by the rules that the institution imposed on them. Much the same seems to be true of the male-dominated University, which treated all the women's Societies with a curious ambivalence. Most of the Diary concerns the events of one term in their second year. The impression it conveys, with great vividness, is of the enormous

enjoyment and satisfaction which they took in all aspects of their busy lives here. Perhaps the most appropriate subtitle for it would be 'Huge chortlings'.[148]

After Christmas 1905 they clearly began to lose interest in keeping a daily record, a process which accelerated as the pressure of academic work grew.[149] We should nevertheless thank providence that they kept it up for as long as they did, and that it survived the vicissitudes of the intervening years to be donated to the College by Dorothy's godson and executor, Richard Whalley, in 1975. It provides an unparalleled insight into the rich daily lives of students at St Hugh's Hall twenty years after its foundation, though hitherto it has been exploited only as the source of occasional period vignettes.[150] It is without doubt the most charming item in the College archive. Read with an eye to the implications of what is said and what is depicted, and to what is written between the lines, it is also uniquely revealing. It needs to be browsed, and savoured.

Margaret went down in 1908 with a Second in History, and became a teacher, initially at their old school. She died on 20 March 1945, at Repton.[151] Regardless of all that flirtation, there is no suggestion that she ever married. Dorothy had gone down in 1907, with a Second in English Language and Literature. What she did next is another indication of how very different Edwardian England was. Immediately on leaving Oxford she secured a position as a lecturer at Bishop Otter Training College, Chichester, an Anglican establishment for the training of women elementary school teachers. She also moved back into her parental home at 37 North St.,[152] because her father, the Rev. Edwin Hammonds, had been the (prodigiously energetic) Principal of the College since 1897.[153] She was appointed to train teachers in her father's College, without ever having taught in a school herself. However, the main reason for her appointment is unlikely to have been nepotism, but rather the unusual character of Bishop Otter College. It had been founded in 1873 to prepare 'young women of a better class' for careers in elementary schools.[154] The appointment of an Oxford-educated lecturer must have represented a considerable coup in raising the social as well as the intellectual tone of the institution. Dorothy evidently preferred this type of teaching to the sort of career in a secondary school chosen by so many of her contemporaries at St Hugh's, including Margaret. In 1911 she wrote to the Editor of the *Club Paper* to report that she had become particularly involved in student drama, and that she had learnt to play the kettle-drum.[155] One can imagine her doing so with some gusto.[156] In July 1916, in very different times, she reported that she was sticking, 'with Casabianca-like tenacity', to the job: 'The actual work seems sometimes extraordinarily futile in comparison with

the news in the morning paper, but it assumes importance if looked at from the right point of view.'[157] In the same year her brother, Captain Denys Hammonds, was awarded the Military Cross.[158] She was at that point evidently still living in her parental home, and like Margaret, she would never marry. The marriage bar,[159] in force for senior civil service jobs as for teaching until shortly before her retirement, may have discouraged her. No further communications from her were published in St Hugh's periodicals, but she remained in touch to record the bare *cursus honorum* of what became a distinguished career.

In 1927 she was made an H.M. Inspector of Schools.[160] By 1935 she was still an Inspector 'under the Board of Education', and had just moved south to London from Newcastle-upon-Tyne.[161] By September 1936 she was Divisional Director of the South West Division 'under the Board of Education'.[162] In July 1938 she was appointed as Senior Woman Inspector at the Board of Education.[163] By 1947, when she was awarded a C.B.E., she was one of the six H.M. Chief Inspectors at the Ministry of Education,[164] and in 1948 was made a Special Staff Inspector at the Ministry of Education.[165] She retired in August 1949.[166] On retirement, she became a member of the Council of the Girls' Public Day School Trust, to which her own school, Clapham High, belonged (and still does, amalgamated with Streatham High in 1938). When she eventually resigned from the Council in 1966 she was appointed a Vice-President of the Trust, a considerable honour. She died at home on 30 December 1974, reportedly after a pleasant Christmas with friends, and received the recognition of an obituary in *The Times*.[167] The Diary gives a far better sense than this bare *curriculum vitae* of a witty, vivacious, attractive personality, who was evidently very well-suited to a career in education, and who had been formally equipped for that career by her three years at St Hugh's. It must have been a delight to know her.

Notes

1. On all members of St Hugh's mentioned, see A.M. Souter, with M. Clapinson, eds, *St Hugh's College Register 1886–1959* (Oxford 2011). I am grateful to Pauline Adams, Jane Garnett, Janet Howarth, Helen Pike, Geraint Thomas, and Susan Wood for commenting on drafts of this introduction.

2. It became a College in 1911.

3. Somerville Hall and Lady Margaret Hall were both founded in 1879; St Hilda's would follow in 1893.

4. She might well have taken exception to this premature familiarity, but to refer to her throughout as 'Miss Hammonds' would nowadays seem studiedly antique, 'Dorothy Hammonds' unnecessarily verbose, and 'Hammonds' at odds with the intimate nature of the Diary.

5. *Clapham High School Magazine*, Easter 1905.

6. Most entries for the year 1905–1906 are initialled by both of them. They dropped the practice of initialling during Summer Term 1906. Although they have similar handwriting, it is clear that their respective initials are in different hands. Margaret uses a full stop after each initial, Dorothy does not. When Dorothy's initials come first, as is the case in a majority of entries, she evidently wrote the entry. On the nine occasions when Margaret's come first, it is clear that she wrote the entry, as is also clearly the case in the four instances where Margaret's initials appear alone. For Dorothy's responsibility for the sketches, see above, p. 5.

7. Surveyed in most detail in B. Kemp, 'The Early History of St Hugh's College', in P. Griffin, ed., *St Hugh's: One Hundred Years of Women's Education in Oxford* (Oxford 1986), pp. 15–47; L. Schwartz, *A Serious Endeavour. Gender, Education and Community at St Hugh's, 1886–2011* (London 2011), pp. 18–42.

8. Letter to *The Guardian* (an Anglican newspaper, not to be confused with the *Manchester Guardian*), dated 14 May 1886, quoted in Kemp, 'Early History', pp. 15–16.

9. C.A.E. Moberly, in *St Hugh's Club Paper*, January 1889, [p. 5].

10. The obituary in *St Hugh's College Chronicle 1937–38*, no. 10, pp. 10–12, directly contradicts the latter assessment, but confirms that 'it was theology which appealed most to her religious nature and for this she learnt Hebrew.' By Miss Moberly's own account – *St Hugh's Club Paper*, no. 2, January 1899, [p. 4] – Miss Wordsworth had invited her to take the job during a walk up Harnham Hill, outside Salisbury, at Easter 1886.

11. Much later, Miss Wordsworth would write that 'experience has shown that that [a less expensive institution] was in the long run an impracticable idea': A.M.A.H. Rogers, 'Historical Reminiscences', *St Hugh's College Chronicle, 1928–29*, no. 1, pp. 12–16, at 12.

12. *First Report of St Hugh's Hall, Oxford, 1891* (Oxford 1891), p. 5.

13. C.A.E. Moberly, in *St Hugh's Club Paper*, n. 4 January 1900, [pp. 4–5], describes the move and the interior of the new house.

14. G. Battiscombe, *Reluctant Pioneer: A Life of Elizabeth Wordsworth* (London 1978), p. 148, quoting the minutes; Kemp, 'Early History', p. 19.

15. *St Hugh's Hall, Oxford. Report, 1895* (Oxford 1895), [p. 2]; numbers fluctuated, but this was the figure in that year.

16. *Report 1895*, [p. 4].

17. *St Hugh's Club Paper*, no. 4, January 1900, [p. 5].

18. *St Hugh's Hall, Oxford. Report for the Year 1901–1902* (np nd), [p. 3]; St Hugh's Club Paper, no. 7, June 1901, [pp. 3–4].

19. *First Report*, p. 5; *Report 1895*, [p. 3], Regulation no. 2.

20. *First Report*, p. 5.

21. *St Hugh's Hall, Oxford. Report for the Year 1900–1901* (np nd), [p. 4]; *Report for 1901–1902*, [p. 3]; *St Hugh's Hall, Oxford, Report for the Year 1902–1903* (np nd), [p. 4].

22. J. Evans, *Prelude and Fugue: An Autobiography* (London 1964), p. 69.

23. J. Howarth, '"In Oxford but…not of Oxford": The Women's Colleges', in M.G. Brock and M.C. Curthoys, eds, *The History of the University of Oxford*, vii, *Nineteenth-Century Oxford*, Part 2, (Oxford 2000), pp. 237–307, at 244.

24. Howarth, 'Women's Colleges', p. 247.

25. Howarth, 'Women's Colleges', p. 274.

26. Kemp, 'Early History', p. 45 n. 32; Howarth, 'Women's Colleges', p. 274 n. 175.

27. Howarth, 'Women's Colleges', pp. 256–7.

28. A.M.A.H. Rogers, *Degrees by Degrees. The Story of the Admission of Oxford Women Students to Membership of the University* (Oxford 1938), pp. 26–55, for a detailed account by a leading protagonist; Howarth, 'Women's Colleges', pp. 265–7.

29. An Honour School in the subject, therefore open to men too, was established in that year.

30. In 1909 Lord Curzon, Chancellor of the University, attempted to argue that women should be admitted to degrees, but not admitted to Congregation or Convocation, and emphasized that he was a strong opponent of the extension of the parliamentary franchise to women. This ingenious if convoluted logic got nowhere: Rogers, *Degrees by Degrees*, pp. 66–7.

31. D.J. Palmer, 'English', in Brock and Curthoys, eds, *Nineteenth-Century Oxford*, p. 404.

32. The Foreword, dated less than a fortnight after the first entry, is in a different hand from the rest of the Diary. It seems likely that the author was in their year. Only two people in their year had Christian names beginning with R: Rhona Arbuthnott-Lane and Rosalind Farnell. The former appears only once in the Diary, in the final entry, doing 'an unorthodox … cake walk'; the latter is a frequent presence throughout and close inspection suggests that a capital F may have been superimposed on the R.

33. 16 Nov. 1906; cf. 21 Nov: 'Neither of us greatly bucked'; 22 Nov: 'obviously bucked'; 28 Nov. 'very bucked'.

34. The illustration accompanying 22 Nov. 1905 celebrates the long anticipated appearance of sausages at breakfast. Underneath is written in the main hand of the Diary 'Nothing whatever to illustrate. DMH'. This strongly implies that Dorothy was responsible for the sketches; cf. 2 Nov. 1905: 'Nothing further to illustrate today – An unpictorial day – DMH'. Note that where initials are used in the captions of sketches – for instance, 1 Dec. 1905 – they often lack a full stop after each initial, a quirk of Dorothy's.

35. *Clapham High School Magazine*, Easter 1901.

36. J. Evans, 'Editor's Preface (1955)', C.A.E. Moberly and E.F. Jourdain, *An Adventure*, 5th edn, ed. J. Evans (London 1955), p. 17.

37. *Report 1901–1902*, [p. 4]; *St Hugh's Club Paper*, no. 10, January 1903, [p. 3]; *Register*, p. 377, incorrectly records her becoming Vice-Principal in 1905. She is sketched presiding at breakfast opposite the Diary's entry for 29 Nov. 1905.

38. *Report 1903–1904*, [p. 2].

39. *Report 1906–1907*, [p. 3].

40. *Report 1898–1899*, [p. 4].

41. *Report 1895*, [p. 2]; further *Register*, no. 15. She already held her Ph.D. at the time of her appointment, but the university which had awarded it was not identified in the *Reports* until

1903–4, perhaps because that also had the first reference to Eleanor Jourdain's Parisian doctorate.

42. *Report 1900–1901*, [p. 3].

43. *Report 1903–1904*, [p. 4].

44. A list of 'Tutors' without any mention of affiliation to the A.E.W. is first given in the *Report for the Year 1907–1908* (np nd), [p. 4].

45. Margaret read Modern History. It would have been possible for them to take (Classical) Pass Moderations as the First Public Examination for both the History and English Schools, but there is no record in the *Reports* that they (or anyone else at St Hugh's) sat this examination. For a summary of the examination system, see M.C. Curthoys, 'The Pattern of Examinations, 1914', in Brock and Curthoys, eds., *Nineteenth-Century Oxford*, Part 2, pp. 512–14.

46. She is not to be equated with 'the Lady of the House', whose reportedly demotic mode of speech, and repeated appearance in the company of the 'leery' Mr Stephens, otherwise termed 'the Satellite', a household servant, suggest that she is probably a housekeeper, named 'Sue', and perhaps Mrs Stephens: 11 Nov., 23 Nov. 1905; 13 Oct., 16 Nov. 1906. Sue could act as a chaperone: 3 Nov. 1905.

47. 4 Nov. 1905.

48. P. West, 'Reminiscences of Seven Decades', in Griffin, ed., *St Hugh's*, pp.62–243, at 65; Schwartz, *Serious Endeavour*, pp. 25–7.

49. 2, 7, 15 Nov. 1905.

50. 17, 18, 22, 29, 30 Nov., 5, 6 Dec. 1905; 22 Jan. 1906.

51. 7 Nov. 1905; cf. 15 May 1906. For only slightly less unflattering descriptions, see West, 'Reminiscences', pp. 69, 72. For an uncanny echo of 'tyrant' by those who could never have read the Diary, see B.E. Gwyer, 'Introductory Memoir', to Rogers, *Degrees by Degrees*, p. xxii, who also, p. xxi, records Rogers' curious penchant for spectating at fires.

52. 27 Nov. 1905.

53. 16 Nov. 1905. The quotation is attributed to 'Hammonds, Ode to OC.', perhaps standing for Oriental Café (see 1 Dec. 1905, when a group of friends took tea at 'O.C.', and found 'some humour in the band, especially the double bass', who is illustrated with a caption: 'The Double Bass at the O C. We feel he has a musical soul, and the true spirit of the artist, if a "little bit knocked about"'). Lloyd's Oriental Café, at 45 Cornmarket, was replaced by the celebrated Cadena Café, on the same site, in 1906.

54. 7 Dec. 1905.

55. See also *St Hugh's Club Paper*, no. 10, January 1903, [p. 4], which records that the recently appointed Vice-Principal was game enough to take the lead in testing a newly-installed fire-escape chute.

56. L. Iremonger, *The Ghosts of Versailles. Miss Moberly and Miss Jourdain and their Adventure. A Critical Study* (London 1957), p. 88.

57. *First Report*, pp. 3–6; *Report 1895*, p. 3, Regulation no. 8: 'Students are required to ask leave of the Principal before accepting invitations from friends. The gates are locked at nine o'clock'; *Report 1900–1901*, [p. 3].

58. Moberly and Jourdain, *Adventure*. For contemporary students being taken in to the Vice-Principal's confidence, see J. Evans, ed., *The Trianon Adventure. A Symposium* (London 1957), pp. 98–103. For a much more sceptical assessment, see Iremonger, *Ghosts of Versailles*.

59. 'Foreword'.

60. See the occasionally waspish descriptions of Freshers under 13 Oct. 1906; and the far more assertive assessments of 'Atalanta', 'Lucy,' and 'Nausicaa' which are appended to the Diary.

61. 9 May 1906; cf. 13 Oct. 1906. By this stage, it is more difficult to determine whether Dorothy or Margaret wrote an entry, because they had dropped their habit of initialling them. But the handwriting in both cases appears to be Dorothy's.

62. [11 May] 1906.

63. 16 Nov. 1905, with the new sketch reportedly added on 11 May 1906.

64. Entry following 9 Nov. 1906.

65. 13 Oct. 1906, when she arrived as a Fresher. Her membership of St Hugh's is not recorded in the *Register*; she is named as Princess Lydia Wiasemsky, from St Petersburg, in *St Hugh's Club Paper*, no. 15, August 1907, [p. 6]. She stayed for only one term.

66. On 6 Nov. 1905 they were both unsure whether they had glimpsed 'Hon. H.L.' in the distance (and the distant bicycling figure is illustrated). On 10 Nov. 'a beardless upstart' had appeared 'who poses as Hon. H.L.', though 'nothing but the genuine article satisfies us.' On 13 Nov. they learnt that his maiden speech at the Union had been a great success – 'a foretaste of the brilliant orator of the future.' On 21 Nov. he is first characterised as 'the Pride of All the Beauchamps' in an entry written by Margaret; cf. 23 Nov. On 27 Nov., in an entry written (and illustrated) by Dorothy, he is 'PERK PERSONIFIED. THE BRITISH ARISTOCRAT'; but on the following day she took exception when another undergraduate described him as 'prosy in parts'. On 30 Nov. it is recorded that he had become President-Elect of the Union, though next day reservations were expressed about his 'horsey and common but nevertheless charming' garb (also illustrated). On 6 Dec., Margaret wrote that spotting him was 'becoming such a daily occurrence that there would be no need to record it but for the fact that he was observed to be smoking a cigar'.

67. R. Davenport-Hines, 'Lygon, William, seventh Earl Beauchamp', *Oxford Dictionary of National Biography*, for the extraordinary story of the earl's fall from grace and flight into exile.

68. 7, 21, 27, 30 Nov., 6 Dec. 1905.

69. 1 Dec. 1905.

70. 30 Nov., 6 Dec. 1905.

71. 2 Nov., 1 Dec. 1905, cf: 'What about this for an angel?', below p.140.

72. 3, '26' (*recte* 25), 30 Nov. 1905.

73. '26' (*recte* 25) Nov, 1905.

74. 6 Nov. 1905.

75. 28 Nov. 1905.

76. 3 Nov. 1905. None is mentioned at the tea on 12 May 1906. Perhaps they were simply a matter of routine.

77. Edith Wardale, 'Some Early Reminiscences of St Hugh's College', *Chronicle 1930–31*, no. 3, pp. 10–13, at 12–13; cf. 22 Nov. 1905.

78. *First Report*, [p. 5].

79. 16 May 1906.

80. 23 May 1906.

81. 21 Nov. 1905: 'The Blot', 'Shelley', 'Sam'; cf. 14, 16 Nov. He was also called 'the little hog': 27 Nov. 1905. There was an undergraduate at Worcester called A.N.C. Shelley, who appears to have been prominent in the Union. It is not clear whether he is 'Shelley'.

82. 3 Nov. 1905.

83. '25' (*recte* 24) Nov. 1905.

84. 16 Nov. 1905.
85. 28 Nov. 1905.
86. 23 Nov. 1905.
87. 10 Nov. 1905.
88. Cf. 28 Nov. 1905.
89. 27 Nov. 1905.
90. 17 Nov. 1906, cf. 6 Dec. 1905.
91. Though note the sketches accompanying 16, 30 Nov. 1905, 26 Apr. 1906.
92. And not just British. 1905 was even more eventful in Russia, a subject on which Eleanor Phillips delivered an 'excellent address' on 6 November.
93. G.P. McGregor, *Bishop Otter College and Policy for Teacher Education, 1839–1980* (London 1981), p. 143.
94. *St Hugh's Club Paper*, no. 14, August 1906, p. 6.
95. *St Hugh's Club Paper*, no. 15, August 1907, [p. 6].
96. 15 May 1906.
97. This was a topic for further discussion in St Hugh's on 5 May.
98. He had joined the Liberal Party in 1903, because he was an ardent free-trader.
99. Tuesday 1 May 1906; cf. *Club Paper*, no. 14, August 1906, p. 6.
100. 16 Nov. 1905. The motion was 'That in the opinion of this House the inevitable tendency of Russia to attempt Asiatic expansion is a complete justification of the Anglo-Japanese Alliance.' The Magdalen man who spoke fourth – therefore for the opposition – was A.C.P. Mackworth. For assessment of another Union debate, 'that this House would regret the identification of the Conservative Party with Mr Chamberlain's fiscal proposals', see 23 Nov. 1905; for yet more criticism, 30 Nov. 1905.
101. In 1879 they were offered use of its library, but the offer was declined: Howarth, 'Women's Colleges', p. 273. Even after their admission to the University, they remained excluded from membership of the Union until the 1960s.
102. 7, 15 Nov. 1905.
103. 5 Dec. 1905; *St Hugh's Club Paper*, no. 14, August 1906, p. 6.
104. 21 Nov. 1905.
105. 5 Dec. 1905.
106. *The Fritillary*, no. 37, March 1906, p. 612.
107. C. Mackenzie, *My Life and Times: Octave Three 1900–1907* (London 1964), p. 116. In the event, the highest he ever rose in public life – as Mackenzie snidely pointed out – was Chairman of the Fire Brigade Committee of the London County Council. He stood for Parliament four times, in the Conservative interest, but was never elected.
108. 15 May 1906; *St Hugh's Club Paper*, no. 14, August 1906, records that 'the motions have frequently dealt with political subjects and have always produced an animated discussion.'
109. *The Fritillary*, no. 38, June 1906, p. 635.
110. *St Hugh's Club Paper*, no. 14, August 1906. Note the archness of tone, reminiscent of Dorothy herself.
111. 4, 28 Nov. 1905.
112. 4 Dec. 1905.
113. *St Hugh's Club Paper*, no. 15, August 1907, [p. 6].
114. Cecilia Ady, who was soon (1909) to return as a History Tutor, and Ada Hales, who read English. They had both come up in 1900.

115. *St Hugh's Club Paper*, no. 16, August 1908, [p. 4]. The Vice Principal reported that 'the two French doctors' gowns provoked a good deal of attention and speculation. It was interesting to be hailed as the Archbishops of Canterbury and York ...' As she and Edith Wardale headed the St Hugh's part of the procession, it seems likely that she had forgotten that Miss Wardale's was a Zürich doctorate. Neither Dorothy Hammonds nor Margaret Mowll (who was still up at St Hugh's in the summer of 1908) is included in the list of St Hugh's participants in the procession.

116. *St Hugh's Club Paper*, no. 14, August 1906, p. 6.

117. *St Hugh's Club Paper*, no. 15, August 1907, [p. 6].

118. *The Fritillary*, no. 37, March 1906, pp. 618–19.

119. 4 Nov. 1905.

120. 2, 6, 20 Nov., 4 Dec. 1905. 30 Apr., 8 May 1906. This society engaged in a variety of activities, chiefly country walks and visiting old churches (week ending 28 Apr. 1906, with illustration; Monday 30 Apr.). It is not mentioned in the *Club Papers*, though there had been an Architectural Society since 1898: *St Hugh's Club Paper*, June 1898, [p. 4]. 'The regulations of the Society' had something to do with the appreciation of architecture: 30 Apr. 1906. It is difficult to decide precisely what the initials stood for: Hall/Hugh's/Historical Tramping/Touring Society?

121. 18 Nov. 1905, 5 May 1906; *St Hugh's Club Paper*, no. 16, August 1908, [p. 6].

122. Sketch for 6 Dec. 1905.

123. *The Fritillary*, no. 38, June 1906, pp. 631–2. Much of the poem is concerned with umlauts.

124. Ernest de Selincourt, holder of a Common University Fund lectureship, was a particular favourite: 8, '25' [*recte* 24] Nov., 6 Dec. 1905, 16 Nov. 1906; for Arthur Napier, Merton Professor of English Language and Literature, see 6, 10, 17, 20 , 27 , 28 Nov. 1905, 9, 16 Nov. 1906; for 'Herbert', see 7 Nov., 7 Dec. 1905; for 'the Pixie' (or 'Beast'), see 1, 22 May 1906.

125. '26' [*recte* 25] Nov. 1905.

126. 14 May 1906.

127. 6, 13, 20 Nov. 1905.

128. 14 Nov. 1905. As in girls' schools, it was normal practice that all parts would have been played by women.

129. 7 Dec. 1905.

130. 23 Nov. 1905.

131. 3 Nov. 1905.

132. 8 Nov. 1905, 23 May 1906.

133. 16 May 1906. In both 1906 and 1907 she was Captain of the Oxford Students' Lawn Tennis Club, and was one of those chosen to play against Cambridge. In 1907 she and Maude Mack defeated all their opponents in the Inter-Collegiate Match: *St Hugh's Club Paper*, no. 14, August 1906, p. 7; no. 15, August 1907, [p. 6].

134. It is initialled 'D.M.H.' – contrary to her normal practice in the Diary, she put a full stop after each initial.

135. 1, 11, 22 Nov. 1905, 9 May 1906.

136. 3, 9 Nov. 1905.

137. Above, nn. 22, 50.

138. 18 Nov. 1905.

139. 23 Nov. 1905.

140. In 1891 the extra charge was 6d a day: *First Report*, p. 5.

141. 16 Nov. 1906; cf. above, n. 65. It is unclear whether this incident had something to do with Princess Wiasemsky's departure after just one term.

142. 11 Nov. 1905.

143. 23 Apr. 1906.

144. 14 Nov. 1905.

145. 22 Jan. 1906.

146. 8 May 1906.

147. 10 Nov. 1905.

148. 30 Nov. 1905.

149. Week ending 28 Apr. 1906.

150. West, 'Reminiscences', pp. 65, 69–71, 74–6, 78–9, 86. The Diary does not feature in Schwartz, *Serious Endeavour*.

151. *St Hugh's Chronicle 1949–50*, no. 22, p. 15. That her death was not reported until five years after the event confirms that she had lost touch with the College.

152. *Report for 1906–1907*, records her as 'Assistant Mistress, Bishop Otter's College, Chichester'; *St Hugh's Club Paper*, no. 15, August 1907, [p. 6]. The house has not survived.

153. McGregor, *Bishop Otter College*, pp. 124–50. His daughter inherited not only his commitment to women's education, but also his vivacity, and his 'racy' prose style (p. 141).

154. *The Times*, 20 June 1872; E.A. Pratt, *A Woman's Work for Women, Being the Aims, Efforts and Aspirations of 'L.M.H.' (Miss Louisa M. Hubbard)* (London 1898), pp. 18-20. The Report of the Cross Commission on Teacher Training (1886–88) records the evidence of a previous Principal of Bishop Otter College, Miss Trevor, lamenting the fact that she had been 'obliged in the last two years to take a few pupil-teachers who are not quite of the class we would wish.' When asked if the College had admitted the daughters of 'shop keepers and artisans', she responded 'I do not think we have ever had anyone of so low a class as that …': quoted in F. Widdowson, *Going Up into the Next Class: Women and Elementary Teacher Training, 1840–1914* (London 1983), p. 35.

155. *St Hugh's Club Paper*, no. 19, August 1911, p. 26.

156. On 21 Nov. 1905 she entertained a party by whistling 'See [*sic*] the Conquering Hero Comes', and accompanying herself on a tea cup.

157. *St Hugh's Club Paper*, no. 24, October 1916, p. 25.

158. He was killed in action in 1918.

159. There was only a partial marriage bar for female elementary school teachers before 1914, and it was conventional for secondary school teachers to resign on marriage. Between 1921 and 1923 most Local Education Committees imposed a marriage bar for all local authority schools: A. Oram, *Women Teachers and Feminist Politics, 1900–1939* (Manchester 1996), pp. 26–7, 59, 62–3, 69–72.; more generally, R. McKibbin, *Classes and Cultures: England 1918–1951* (Oxford 1998), p. 48.

160. *St Hugh's Club Paper*, no. 29, April 1927, p. 5.

161. *St Hugh's College Chronicle 1934–35*, no. 7, p. 32.

162. *Chronicle 1935–36*, no. 8, 'Association of Senior Members Report', (separately paginated in this issue), p. 26.

163. *Chronicle 1937–38*, no. 10, p. 40.

164. *Chronicle 1946–47*, no. 19, p. 33.

165. *Chronicle 1947–48*, no. 20, p. 28.

166. *Chronicle 1949–50*, no. 22, p. 23.

167. *The Times*, 6 January 1975; repr. in *Chronicle 1974–75*, no. 48, p. 26.

DRAMATIS PERSONAE

The College *Register** has been used to identify the names of many of those referred to by initials in the Diary. This has not been possible in every case. No systematic attempt has been made to identify others, also known by their initials, who were not members of St Hugh's.

M.B.	Maud Baker
P. de B. B-C.	Peggy de Billinghurst Bowen-Colthurst
M.C.	Mary Cornish
L.D.	Lilian Dawson
R.F.	Rosalind Farnell
G.C.H.	Gertrude Hough
R.W.G.	Rhoda Goddard
D.M.H.	Dorothy Hammonds
O.F.H.	possibly Oliver Huyshe, Keble College
M.H.	Miriam Hirst
E.J.	Eleanor Jourdain, i.e. V.P.
M.A.K.	Margaret Keeling
Lettuce	(*recte* Lettice) (Fisher), History Tutor
Hon. H.L.	Hon. Henry Lygon, Magdalen College
M.L.L.	Maria Lardelli
M.K.M.	Margaret Mowll
M.I.O.	Mary Ottley
E.A.P.	Eleanor Phillips
H.M.P.	probably Herbert Pope, Lincoln College
M.P.P.	Margaret Potter
P.O.P.	Professor of Poetry
V.P.	Vice-Principal, i.e. Eleanor Jourdain
A.M.A.H.R.	Annie Rogers, Classics Tutor
D.W.S.	Dorothy Sprules
G.M.S.	Gertrude Seelly
G. N-S.	Grace Nugent Smith

* A.M. Soutter, with M. Clapinson, eds, *St Hugh's College Register 1889–1959* (Oxford 2011).

L.S.	probably Lelio Stampa, History Lecturer, Exeter College (and A.E.W. Tutor)
Sue	Probably the Housekeeper, possibly Mrs Stephens
Mr Stephens	Hall servant
L.F.T.	Louisa Todd
L. von V.	Ludmilla de Vogdt
G.W.W.	Gwendolen Watson
W.W.	Winifred West

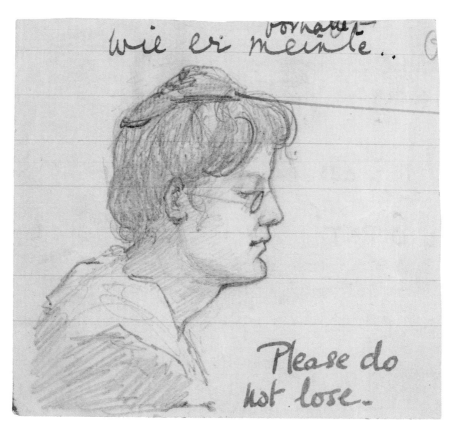

A detached sketch, which perhaps depicts Edith Wardale
imparting the rigours of Germanic philology.

DIARY

The Diary's front cover, decorated with suitable symbols, presumably by Dorothy.

A Foreword.

I have much pleasure in bringing before the public this admirable little work. To call it a gem is hardly to do it justice. It is indeed a threefold gem. It scintillates as the brightest diamond, glows with life as the blood red ruby, and is a very pearl in its simplicity and girl-like naïveté.

To all those who have a real desire to understand the inner life of the woman student, to all those who feel in need of mental refreshment, to all anxious to know girl nature as it really is, I can confidently recommend the following pages. Full of subtle humour, of delicate unhurtful wit, of unaffected pathos, abounding in passages of real intellectual depth & psychological value, this work is by no means to be set aside lightly or read patronisingly, as the outpouring of two young minds. A true vein of earnest piety runs through the whole diary and none but the most impudent of sceptical scoffers can fail to be impressed by this earnestness of purpose.

To close this foreword without a word as to the really exquisite little sketches which accompany each entry would be to deprive the work of half its value. The execution of each one is perfect in its general intended impression & its rigid adherence to realistic detail. Nevertheless unkindness & too much personal realism are quite alien to the spirit of the artist; and great praise & no little wonder are due to her, for the admirable skill with which she makes each figure tell its own tale, while not one of her friends could justly use in the dignity of her insulted womanhood, and accuse the little pencil-wielder of caricature or personal reference.

At the risk of appearing too infatuated with the genius of these two fellow workers of mine, I feel constrained to end with 2 lines of poetry which I cannot but feel are admirably appropriate.

Two women were, of humour and of art profound
On whom nor wisdom, nor wit, nor critic ever frowned.

R.

St Hugh's Hall
Oxford.

12th Nov. 1905.

·HALLOWEEN·

TRIUMPH

THE STRUGGLE

RAISIN DIGGING

Tuesday - October 31st 1905.

Both down in time - No morning events.
Tea with the Dons - MKM with E.I.
D M H - L. D

No 'Varsity news to record today - (unfortunately)
In the evening a Second Year Gathering took
place in our room at 9.15. EC Hough being
joint hostess. The proceedings followed the
well known "Halloween" customs

Bob. Apple -
Raisin digging -
Cake cutting -
Story telling - Chestnut roasting -

The room was lit by two candles (borrowed.)
The 'Bob Apple' honour is due to R.F who
caused most amusement (in fact could be heard
in the other house) May Ottley cheated openly
at raisin digging, while Ludmilla carried off
the ring from the cake in more senses than one -
G C H roasted the chestnuts with some success,
and sat perilously near their exploding skins -

Earlier in the evening glad news of D M's Engagement
arrived. The Diary offers congratulations.
(Signed & adopted.) D M H - M.K.M

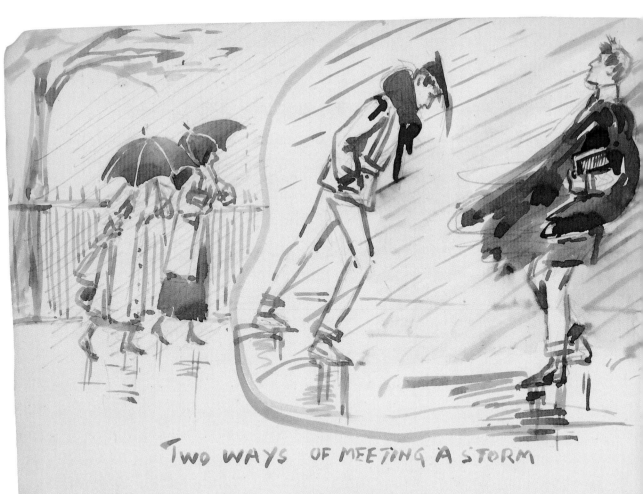

TWO WAYS OF MEETING A STORM

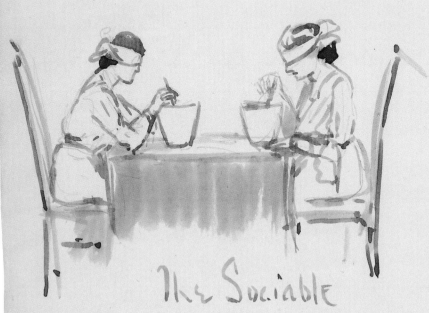

The Sociable

Both down in time, though rather a scrape as far as
MKM is concerned — Sausages for breakfast.

Varsity news. 'Rat' seen in Corpus Quad by MKM —
 Great inquisitiveness shown by the rest of the Hall anent Hallowe'en festivities.
 A quiet afternoon with the misses, varied by
discussions & studies on physiognomy — MKM thinks
she has a weak face —
 Scratch tea with R.F. Entertainment supplied by forced
laughter, and acrobatic feats.
 Coaching for both ended in both being late for
dinner — a scratch meal owing to general exodus
to Classical Concert. Abbreviated prayers & no hymn
also in consequence —
 Viva voce Examination in Hymn tunes conducted by DMH.
MKM a dead plough —
Evening ended by Sociable — Progressive Games —
Neither of the members of this Room obtained any
distinction worth recording, poor at peas, poor
at pins, middling at 'tiddley winks, &c. MKM
rather low about not winning — DMH callous, tho'
having got a red pencil for Consolation's sake —
 It must be here recorded that it has rained
almost incessantly today, but no lives have been
lost by drowning or swamping, fortunately — L.S.
stated that in the year 1903 there were six floods
& that Hilary Term 1904 was a record for dryness —
 Signed & adopted. DMH. MKM.

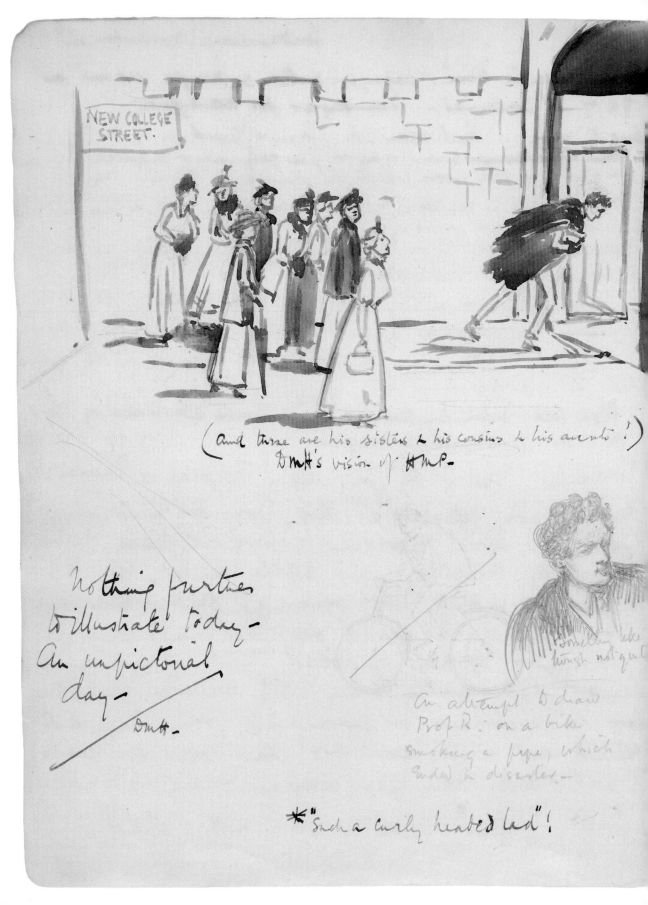

NEW COLLEGE STREET.

(and these are his sisters & his cousins & his aunts!)
DmH's vision of HMP.

Nothing further
to illustrate today—
An unpictorial
day—
— DmH.

An attempt to draw
Prof R. on a bike
smoking a pipe, which
ended in disaster—

Something like
though not quite

★ "Such a curly headed lad"!

Both down in time. M. K. M. attempted work before
breakfast — An uninteresting meal.
<u>Varsity News</u>. H. M. P* seen by both, though on divers
occasions. D. M. H. saw Prof. R. smoking pipe.
Another strenuous afternoon with the Muses.
Tea at L. M. H. A deadly affair. Nothing to
eat and nothing to talk about. Came
away early out of sheer boredom.
L. M. H has still some things to learn of S. H. H.
5 - 7. 30. Worked hard, a fact worth recording.
Dinner a notable affair as far as D. M. H
concerned. Aspired to sitting at High
having secured the promised support of
M. K. M, but was basely deserted at the
last moment. Without coaching from the
H. T. S. this experiment must not be re-
-peated. Silence reigned supreme.
Oh! for the future Foreign Politics, Home
Politics, and Miscellaneous, Literature
and Art (supplied by the Literary Supplement)
and all those other aids to Rhetoric!
We cannot help recording that this Thursday
evening has been misspent this Night of
all Nights has been no Night for us! (No
Union Tickets.) Both deeply stirred, however,
by anticipatory invitation to Balliol Breakfast!
Signed & adopted M. K. M & D. M. H.

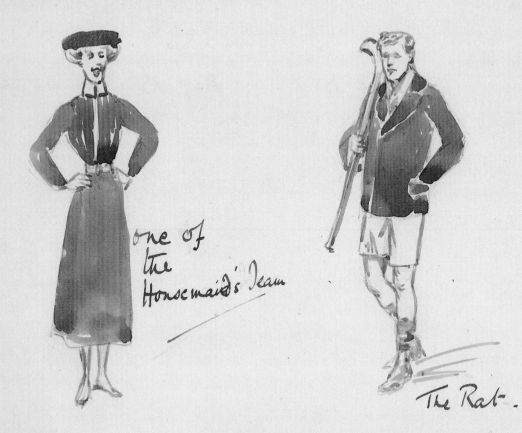

one of
the
Housemaid's Team

The Rat.

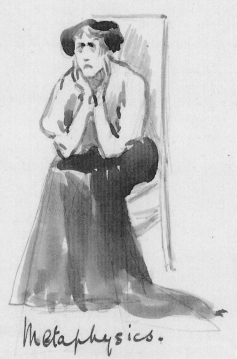

Metaphysics.

Both down in time. MKM called three times — rose at the third unwillingly, though just in time.

Varsity News. — D seen in Queens Lane, smiling.

Rat seen by MKM going to hockey — OFH also seen ploughing through the mud in slippers —
DMH played in the most unpleasant hockey match she ever experienced, in fact against a team of house-maids. Their name shall not be recorded — May they never reach posterity (nor may the score they made against us!)
MKM celebrated the afternoon by a visit to New Coll: personally conducted by Sue — This was the result of deplorable ignorance manifested at lunch anent Winchester — Sue dismissed in Long Wall Street, while MKM hurried back to put the kettle on, and await in trembling anxiety the arrival of the food — General scramble, but in the end all in readiness for CJBS who came ten minutes late — Desperate pumping, with excellent results — We know Varsity life better than we did. Unfortunately little news gleaned in the right direction!)
The Earl being due at 5.30, CJBS, son of Sir J.S; KC, LCB, KCMG, was hastened unceremoniously off the premises at 5.25 — We can't mince matters at St Hugh's.
DMH dined with RF at the small table. Some humour:—
I planted a kiss. What came up? — Tulips (two lips!!!)
I planted Father's scissors " " "? — Parsnips — (pa—!!:!)
DMH yawned over metaphysics for half an hour, & looked intelligent. MKM spent the time otherwise.

Acting Committee of Charades met in this room 9.30.
MKM. DMH. MIO. GCH. RF — Impromptu Rehearsal —
MIO appears as Lettuce, MKM magnificent as Herbert, while DMH & RF do the common as if born to it.
Extracts from Mrs Green end a pleasant day
Signed & adopted. DMH MKM

Mrs Balliol
Calls.

M K M
addresses the
listening throng.

Saturday November 4th

Both down in time - easy. D. M. H. had High breakfast.
She shewed hopeless ignorance on Railway System
of our country.

Varsity News Nothing to report although M. K. M. went
down to the town for the purpose.

D. M. H inspected Oxford Art at the Clarendon Hotel.
She finds that her ideas on Art do not correspond
with those of the Varsity.

M. K. M. manages tea well — gets two in, in the
space of one hour. Tremendous favourite with
the S. S. Proud as Punch in consequence.

D. M. H. has "Chats with Charlie" in the apartment
of K. 4. Productive of some humour.

On her return is visited by Mrs Balliol ushered
in by the Lady of the House with great flourish.
Mrs B. returns later to call on M. K. M. same
ceremony — hopeless explanations.

Both attended Society for the Propagation of
Cheap Repartee. M.K.M. leads the Opposition
coached by D. M. H; the motion being "Man
is given speech to disguise his thoughts"
Style said to be Unionistic — What higher
praise can man or woman seek?

An ugly woman, one of the ugliest is
staying in the house. They say she is
related to Sue. D. M. H. will have BICYCLE
on the Brain for the third time this term. She shed
will be at the disposal of any passing kleptomaniac.
Signed + adopted. MKM DMH

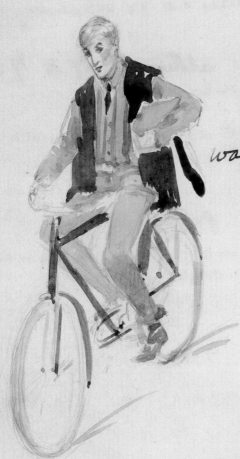

was it?

The acquisitions —

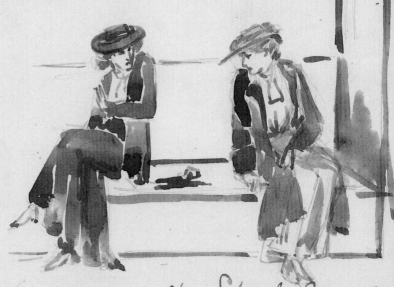

The Schools Tragedy

Monday, November 6th.

Both down in time - Margaret was up with the lark, no breakfast items.

<u>Varsity News</u>. The question is, <u>was</u> Hon. H.L seen by either, or both of us (or neither) this morning? None will ever know, but each has her thought anent.

Shelley more than ever a blot on the landscape, though he thinks he improves the front of the Schools.

D.m.H with the help of RF left her mark for ever on the Schools, in the form of a large ink stain in Room 8. The implements of the tragedy, ink & pink blotting paper (stolen from A.E.W) abandoned in the solitary wastes of the Parks. There they tell their silent tale.

Mrs M takes tea in our room (buttered tea cake) and leaves two pots of Jam, which we hope will help to kill off the Freshers. (metaphorically speaking.)

A very Don-ny Dinner. D.m.H L.D.
M.K.M Sue + Visitor, an archaeological specimen, who has travelled far & seen much. She looks like it, with weather beaten visage and flowing moustache. Resumé of Prof N's lecture with additions by M C keep L.D's table alive.

Shakespeare Society interesting. The immortal Bill's character of Falstaff admirably interpreted by M.10, with careful omission of swear words - So good - M.K.M & D.m.H are not honoured by "speaking" parts, but are told they are very important.

1st Meeting of the H.T.S - RF in the chair - Cakes & Ale. M.K.M opens proceedings with dissertation on Home Politics, Comprehensive if not Exhaustive, Athletics & Sport touched upon. M.K follows with awkward questions culled promiscuously from Whittaker for 1904. Little response, but much applause - hilarity hides ignorance - E.A.P delivers excellent address on Foreign Politics, in her best manner. Remarks confined to Russia & extremely well sub divided. D.m.H closes meeting with a few well chosen remarks on Literature & Art gleaned with much pain & tribulation from the Litt: Sup:

Bath and Bed.
Signed & adopted D.m.H. + M.K.H.

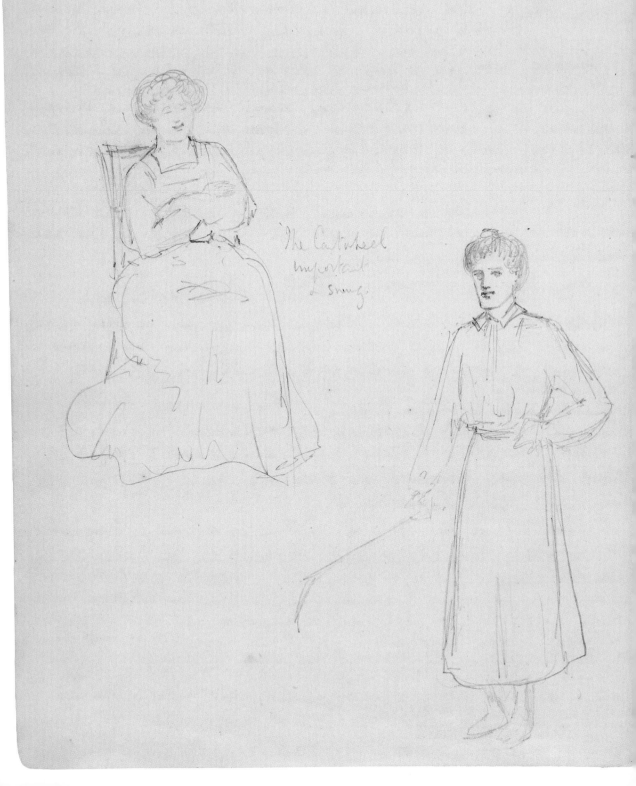

The Cartwheel
important
snug.

Both down in time. Easily accomplished despite cold. M.K.M breakfasted at High, not so D.M.H who grabbed a good place among the chosen.

Varsity News. M.K.M. saw H.M.P. but does not seem so elated as occasion deserves. Herbert quite humourous. D.M.H. has had no luck to-day.

D.M.H was driven to the Muses in the shape of Miss D. who coaches at Somerville.

M.K.M. played the noble game of Hockey in her accustomed style & returns to tea with L.V. Has the supreme pleasure of meeting A.M.A.H.T.R. viz— the Vampire of the A.E.W. The self tyrant of the classical students. The bully of all beginners. She is a woman(?) who has brutality but not wit, force but no humour, (she has a nose)

D.M.H has tea in Library — a Sunday School-treat meal.

M.K.M. dines at High, D.M.H again more at her ease among the chosen. We have before stated some reasons for avoiding the High.

D.M.H has a quiet evening with E.A.P & the Muses. M.K.M attends the O.S.D.S. less dull than usual. Subject debated "That environment determines character." She cartwheel all important and very smug. Let us not refrain from comparisons and contrasts between this and another Oxford Debating Society of even greater fame.

A measly day! Signed & adopted M.K.M. D.M.H.

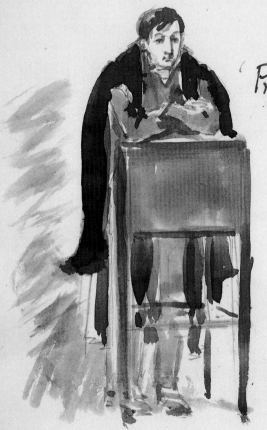

'Prof. de Sel'

Nothing else
worth picturing.

"Wednesday. November 8th"



"Both down in time, though the closest affair we have had this term. DMH, with great self denial, spends the time from 7.15 to 7.40 calling MKM almost incessantly, & is met by the cheery remark "I do like to hear you calling me". Ingratitude thy name is woman! Varsity news. Absolutely none.

DMH did hear a lecture by "Prof: de Sel." which wasn't bad, but what is such news as this among the possibilities of Varsity life?

DMH wins distinction at Beowulf Class for her remarkably happy rendering of the O.E. text, and for her bright answers in philology.

MKM attempted an afternoon with the Muses, but they did not find them attractive today. Far be it from us to hint that she usually finds them dull!

The Second Year "pairs" practised this afternoon on the Cherwell. It must be recorded that the Second Year has now put a boat on the River, which if occasion requires & with careful Coxing should easily bump Somerville.

Two freshers satisfactorily ticked off at tea. Humorous stories by G.CH. "A spider, turned from its ancient resting place under the pulpit cushion by the vehemence of the new preacher, wanders down the aisle in search of a home - Is met by another spider who says. Join me in the Missionary Box. that's never disturbed."

No dinner items. DMH's double is here, but is more different than ever - Rehearsal of Charades. We have learnt a charming ditty.

"All the girls are loverly, overly
"All the girls are nice
"Whether they wear their hair in bangs
"or over their dear little ears it hangs.
"Whether they're twenty, thirty, forty, fifty or fifty three
"All the girls are loverly-overly,
"- overly to me! Signed & adopted DMH. & MKM."

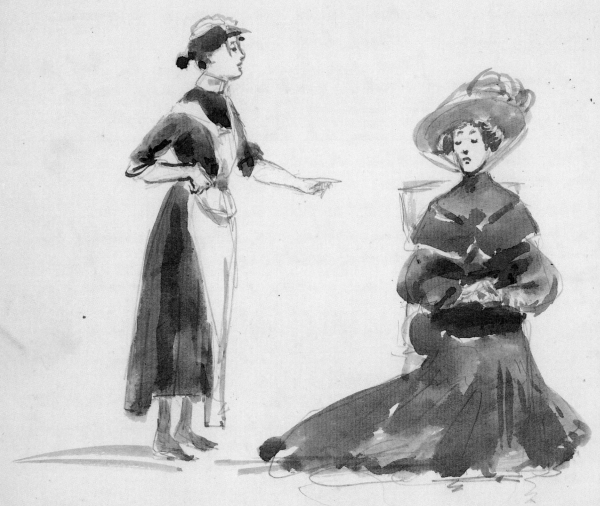

E.— Where's yer rapron?
V.P.— Ladies don't wear aprons — there's
tilte in everythink!

Both down in time. M.K.M discussed Lord Mayor's show at
high with little success.

Varsity News. We regret that again to-day all efforts have
been in vain. There is still nothing out of the common
to record.

Lunch and Hockey occupied till the 4th hour
post meridian.

Two freshers more ticked off our account. We
gave them good tea and good company - M.1.0
was uninvited but welcome.

Spent the evening till after dinner in one
continual worry anent charades. D.M.H
+ R.T. looked out trains for early departure
while M.K.M. ate no dinner in a frenzy of stage
fright which even affected her powers
of speech. This is an unusual occurrence.

Against our wildest hopes and expectations
our tentative efforts were received with
applause, nay real mirth. We really
were rather good! + Mr & Mrs Dolphin were
in one of their happiest moods. Jiesferson
was deep and sympathetic, while words
fail us to describe Mr Hallcum's kind condescension.
+ dis in the display of his genius.

Veronica Perkins shewed she was a real
lady, quite one of the smart set, while nothing
could raise Edie from the depths of commonness
and plain unadulterated vulgarity.

Signed + adopted M.K.M & D.M.H.

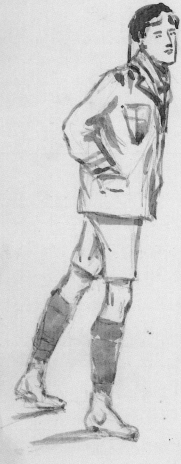

The Bass by the Window —

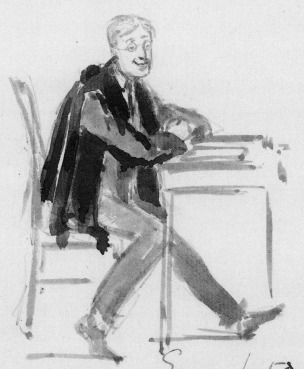

Envy, hatred & malice
& all uncharitableness

Friday, November 10th

Both down in time. MKM again an early bird. We don't know
if she saw the dawn, but we rather think not.

<u>Varsity news.</u> There is a beardless upstart arisen who poses
as Hon K.L. and has taken us both in! We will not
however be baffled by such deception — nothing but the
genuine article satisfies us. DMH has been badly insulted
in company with her friend & confidant R.F. Before Napier
begins, enter undergrad, ugly but funny, dragging in too the veteran
of the Schools, whom he commands to move the Blackboard, so
that he of all others can see more perfectly by this arrangement!
DMH & RF are now deprived of all sight of the Blackboard.
Huge delight of undergrad, who giggles continuously during lecture.
The "Bass by the window" returns from football looking hopelessly
nice.

The only event of the afternoon was Oxford Mission & Calcutta Service.
MS starts first from the Hall. She leaves at 3.20, on a bicycle
the service being at 3.30 & in Keble Chapel (five minutes walk.)
Such is clerical infatuation!

MKM has tea with M.13. She meets the daughter of
the Editing Manager of the Times. Dull affair, though no offence
meant. DMH takes tea with 2 F.T and is also honoured
by meeting the great Miss H—s 'of histrionic fame.

No further events till dinner, where MKM gleans
some humorous anecdotes anent Mr Dolphin.
The maid aged 15, seeing his evening clothes, remarks
"first time I knew master went out waiting!"
Again, when asked why she did not answer the
door, replies "Master met me, and said 'Don't bother
miss, I'll do it for you!'"

'Ignoramae' meeting at DMH. Sheridan's 'Rivals'
read with some success & talent.
One of the best books on Henry VIII is by Pollard, late
Examiner. 'The Rivals' can be bought for 5d if you only try
long enough. — Signed & adopted DMH & MKM.

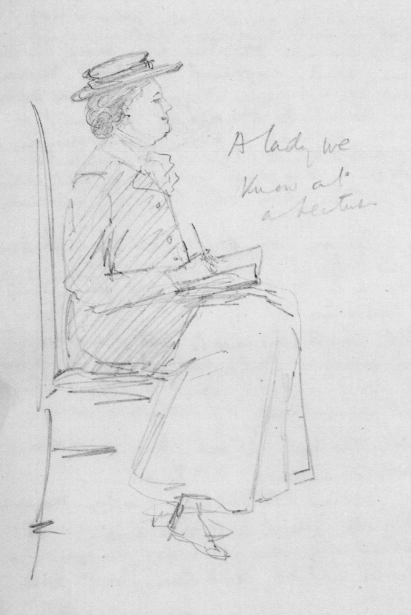

A lady we
know at
a lecture

Both down in time. H.K.M. consulted the Spirits for a very short space before breakfast. D.M.H does not approve of early consultations.

Varsity News No morning items, as neither went out to clean. Both went down town in afternoon with unsatisfactory results. New College Hall was graced this afternoon by the presence of D.M.H & H.K.M to hear about Assyrian Mission. The only object of interest was Dr. Sp——R who however ejaculated no —— icme! We were troubled by an awkward and quite uncalled for collection. It is perhaps gratuitous to mention that G.M.S was at the aforesaid meeting.

H.K.M returns to tea with some old friends J.S.S & R.W.G who were in their usual force.

D.M.H has inevitable Hall tea (bread & butter) with inevitable adjuncts. M.P.P & G.M.S.

No further news.

S.A. Sociable. Father Waffett.

R.Y. has just returned from Rugby, a visit to the 'Miss Browns' Seminary where her sister is immured. We gather that she has made a favourable impression upon the erudite females. This is greatly to her credit, and she herself has said it!

Lamps flare if not attended to.

Pictures on S.H.H. walls never hang straight. The Lady of the House can be overruled by flattery. S.A.P. away for week-end.

signed & adopted H.K.M. Dna.

Falstaff then
&
now —

Monday, November 13th 1905.

Both down in time. This morning saw the departure of a few of the numerous guests who have during this week made their presence felt amongus. We now feel H-A-P-P-Y because we're F-R-EE -

Varsity news. We have had no visual luck today, but MKM has made a charming discovery. Out of sight & out of mind in the Library is a stack of delectable Oxford magazines containing records for several years back, of vital interest. Here we learn that Hon HL's Maiden Speech was a great success in every way; "charming in delivery & fluent in language" he held the House spell bound & gave but a foretaste of the brilliant orator of the future. There were other charming little stories which space will not permit us to record. Suffice it to say that they gave us infinite pleasure.

We regret to say that our sister RF has, during the week end, been on the sick list. However it gives us great pleasure that her indisposition was but a temporary derangement, & now she has returned to her usual bright little self.

We feel that one of those who have lately come to our midst had condemned herself with her own words, which were many & dull. Not only does she take upon herself to keep the conversation going, but she undertakes to make it unutterably boring & aimless. We feel we must inaugurate a School of Rhetoric for such as these, though DMH declines part, it having none too much of the easy gab herself. Shakespeare Society again shows off to advantage the histrionic talents of M10. DMH & MKM have this night said their little say & retired to obscurity. Signed & adopted. DMH HPLR

THE MA

KATE

MR
HARD

Tuesday, November 14th

Both down in time. Sausages for breakfast — we both agree that these sausages are the nicest we have tasted. I think the fact worth recording. N.B. change of sausage from Wednesday to Tuesday — last year they used to serve as compensation for the Litany.

<u>Varsity News</u>. DMH & RF see grey-haired figure in MA gown padding down Queen's Lane. RF exclaims "Too old for such haste!" DMH ~~with some~~ supplies age of MA and also name with alacrity. Scored as an MKM in consequence — Shelley entered No 10 room with Prof: N. looking as though he had had a decided slap.

No lunch news, hockey as per usual —

Hall tea for both, with usual adjuncts.

MKM hired him to the High at dinner & did the pretty. DMH dined early in order to attend the Theatre, or rather St George's Hall, which is at the same time the 'Young Man's Christian Association' & Youth's Mutual resort. ~~That~~ The Home Students this night performed "She Stoops to Conquer". They admitted none of the male sex, <u>except</u>, and this seems to us drawing rather a nice 'distinction', except those who have reached the supreme position of a grandfather. We sorrow to state that out of a packed assembly, only three lone grandfathers could be mustered.

The performance was such as might have been expected ~~both~~ those acquainted with the Home Students. Staging & costume elementary. Sateen takes the place of coloured brocade, panniers are worn but unfortunately in appearance, sake are not padded; while the make-up was piteous! poor Mrs Hardcastle's face savoured of the coal-box, while Mr Marlowe & Mr Hastings looked as though they would have been vastly improved by a good wash. Mr Marlowe moved the house almost to tears by his impassioned, but somewhat belated speech "By Heaven, she weeps!" Mrs Hardcastle was a head & shoulders taller than Tony, while Constance was common. Christopher Marlowe was a fine figure. Signed & adopted DMH. MKM

Reddie -
Enfant terrible -

another

"Here ends
damned dull day" "Dop Day~

Both down in time. D.M.H consulted Muses for whole hour before breakfast. This was caused by stern necessity in shape of A type's class.

<u>Varsity News.</u> For the first time in their lives D. M. H. & M. K. M. meet at A. E. W. Interview affords D M A much amusement, especially sight of L.S. driven to performing in the A.E.W. He stands apart timid and retiring amid the gay throngs of the opposite sex.

No Lunch News.

At 2 o'clock M. K. M attends Committee meeting of the O.S.D-S. where she plays the fool to the great annoyance of Treasurer — a serious and portly woman who feels that the O.S. D.S. may descend into a mere 'rag'. We have no hopes that this will be the case while she is an officer of the society.

Both spend afternoon with Muses.

Tea in hall minus the usual adjuncts. Their absence has not been satisfactorily explained. Was there indeed a Church workers tea or have the tasks of the Churchwarden proved so arduous that they necessitate fasting? Dons to dinner, though why we don't know. M. K. M is booked early in the evening to fill up gaps in conversation at Sub. high. Her efforts were not blessed with success despite pink crêpe de chine. W. W. gives party — shews off lantern slides of glaciers. Family evidently appreciative, though their remarks are sometimes irrelevant. Teddy an impossible child but great good. To-morrow is Thursday. Signed and adopted M. K. M. & D M H

The Librarian
bored.

The Secretary
Mr. Renton.

← A noticeable feature

The Honourable
Opposer.

A later edition
this gent. added on
May 11th 1906.

Both down in time. It is perhaps gratuitous to record that
MKM — but her pride must be kept down.
A good dish at breakfast, eggs cut by the knife, or otherwise
Sardines & eggs — we don't get this often enough —

<u>Varsity news.</u> DMH & RF decide, on close observation, back
and front, that Shelley, the Débauchée, & the Bad
are a disgrace to the Varsity, and rank as mere black
sheep. The 'Varsity' discusses whether Oxford men are
ill mannered? We refrain from any unkind remarks on the subject.

Hockey for DMH, Muses for MKM, or rather, MKM muses,
and DMH is amused when she muses thereon — (laugh here)
A pleasant scratch tea, MKM, DMH & RCH; three
pennorth of halfpenny buns & a robin roll —

DMH has been invited to Concert at New Schools
to go with Cobbs —

An awful rumour reached us that there was no
Chaperon handy, and therefore no Union for us. Now
we had tickets, and we wanted to go. However EJ
arrives with welcome news that we may dare
"unchaperoned to gaze*" upon the members of the
School for British statesmen. With feverish anxiety
MKM & DMH scan the faces of Ex-officers, but in
vain. "Fate went ever thus." ✶ The Debate lost much of
its point in consequence. If the Speakers of tonight
are England's Embryo statesmen the prospects
of the coming are indeed small. We feel we
must refer to the Magdalen gentleman who spoke
fourth. His politics were fanciful & savoured of the
nursery, his style easy & boyish not to say infantile.
He offered the country some good advice, & assured an
✶ incredulous & smiling House that his remarks were quite true.
Hammond. Ode to C. & Beowulf. Signed & adopted DMH MKM
Smudged by DMH. an accident.

Smtt sits for the first
part of Prof de Sel's Lecture smearing
ink on her face with a contemplative air.
Huge mirth of R.F.

Both down in time. Only eggs for breakfast and those of a type we do not recommend.

versity News. Shelley again enters lecture in deep conversation with Prof. N. We don't admire Prof. 's taste. M. K. M saw a figure on horseback which she thought she recognised. Need we say more. *ne* of those who has lately come into our midst has a made a fatal mistake, but never-theless one that has proved a snare to others. She asked an Undergraduate for a Statutes Book 1905 thinking he was an assistant. The undergraduate treats the demand with cold disdain but his companions find the affair productive of humour.

D. M. H played the pianner with Louisa. M. K. M read in Camera.

M. H asked by S. S. to help hand bread and butter *Mrs C.* "Rather a 'type' but quite amusing. An improvement on her daughter.

K. M. had tea *at.* in the high society to which she has become lately accustomed, the visitors being dons. N.B. Her hostess after-wards remarked that M. R. M was very useful in the talking line. Far be it from us to suggest that she has any other use.

The 'Ignoramae' study the 'Ballad' and find it rather a suggestive form of poetry.

Signed and adopted M. K. M.

Freeze, freeze, thou bitter sky!

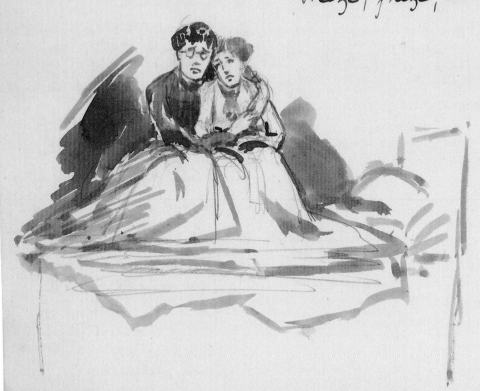

a well known
Oxford figure

Botd. down in time – No breakfast news though both took it in high quarters. Kedgeree (?) for breakfast – Bony, stringy, oniony & hot!

<u>Varsity News</u>. Saturday never supplies us with any tit bits in this direction.

This is the coldest morning we have spent as yet – Driven from our room by the depth of the temperature, driven from the Common room by Kenney, we resorted to the awing, so called! There we find a gibbering company, shivering round a fire which is being encouraged by a newspaper! MKM & DMH try to defy the elements nestling together on the bed (sofa so called) wrapt in sundry blankets – We did not get warm, neither did we get through any work.

Match against Etceras. Hall beaten 5–1. A good match all the same.

Recherché Scratch Tea – DMH, MKM & MC – the latter enlivens proceedings by various racy anecdotes. Here is a sample. Simple aristocrat spends Friday night at Cowley. Not being accustomed to fasts, he feels keenly the pangs of hunger. Is greatly relieved when Brother murmurs outside his door "Dominus tecum", to which he replies " Thanks very much, put it down outside." A good story we think.

MC & DMH repair to OE chat. MC succeeds in hiding her ignorance, & MK displays her knowledge. DMH & RF are strangely silent. "A type" takes it for complete comprehension and is fearfully bucked.

Sharp practice discusses Co-Education with passion and (eloquence?) MKM & DMH both display their rhetorical powers.

Signed & adopted DMH. MKM.

The musical profession

Ludwig

Monday Nov. 20th

Both down in time - One not at breakfast. Cold ham toast.
<u>Varsity News</u> - MKM has the great pleasure of seeing
Shelley as grievous a blot as ever, adorning the front
steps of the Schools - DmH & KF sweep past the
aforesaid little hog like Duchesses, careful to lift their
skirts out of Contamination, MKM, however, asserts that
Shelley has all her sympathy, and is by no means as
black as he is painted. Prof Nap caught almost
swearing. Enter the little Shrimp of the Schools and seizes
duster, whereupon Prof N. Ejaculates with some force
"Damp it!" Great discussion in the class as to what he said.
No lunch news - G.C.H plays in United Match - the Diary
offers congratulations. DmH & MKM muse for an
hour, then Scratch tea with G.C.H.

No dinner news with MKM - Shakespeare Society
deplorably dull - A.J.S proved successful as before,
though three of its most prominent members were
absent. MKM in consequence took charge of
Home Politics - and Miscellaneous which she rattled
off extempory to the awe & wonder of the audience -
"And still they gazed, and still the wonder grew
"How one small head could carry all she knew."
DmH with G.C.H takes dinner with Cobbs, and goes to
musical union Concert. A very enjoyable time.
She sees there two new acquaintances of yesterday, who
are related to friends in Chichester. Driven home in
state - Forgot to mention that met old friend Dr. W.
who examined DmH in piano forte playing at the
age of 13 - Not recognized, however strange it may seem -
Signed & adopted DmH. & M.K.H.

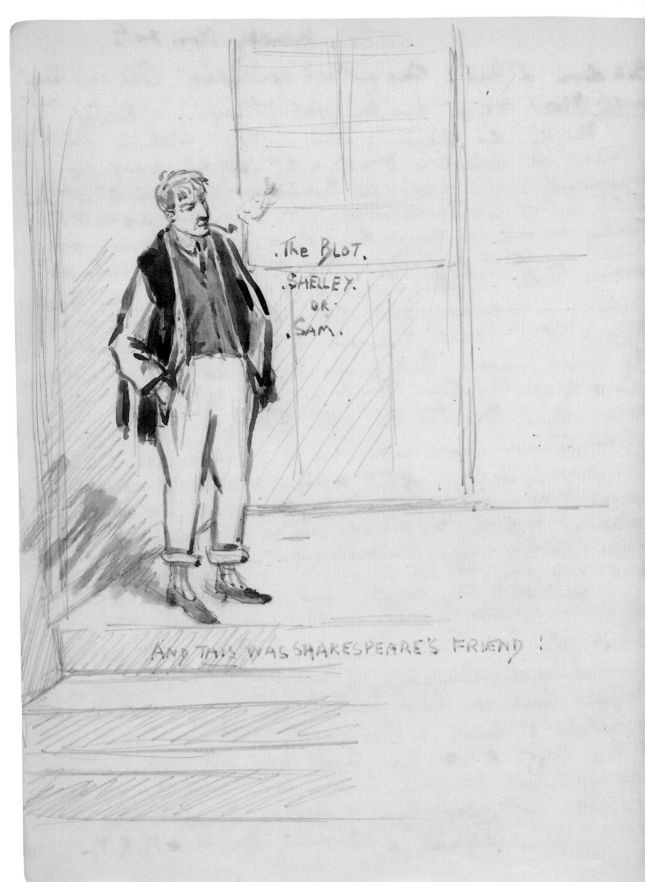

.The BLOT.
.SHELLEY.
OR
.SAM.

AND THIS WAS SHAKESPEARE'S FRIEND!

Tuesday November 21st

Both down in time. M. K. M. was called early, but heeded not the summons. M. K. M. suffered grievous blow at Breakfast — no sausages.

rsity News. This is indeed a day of days. M. K. M has actually seen Face to Face the Pride of all _e_ Beauchamps. This is the first time he has _een_ seen accidentaly and in the flesh. Thus _e_ need of capital letters. Shelley is learning _manners._ We notice with gratification that he _removes_ his pipe from his cherub mouth _s_ to M. H. & K. M. pass. M. K. M.'s opinion somewhat _stified._

Some lunch news. The Hall congratulates itself on retaining English Essay prize in hands of M. A. K.

M. H. has tea with R. L. after an interesting coaching. K. M. & G. C. H. go to tea with Mrs Massey. Maynard _om_ Oriel gives dissertation on golf. M. K. M. & G. C. H _ot_ well up in subject, but "pretend they know a lot" _spitatcalls._ Neither of us greatly tucked.

oth of us again impressed with essential _ifferences_ between male & female debating _apacities_ and gifts of oratory. We are also _onvinced_ of advisability of preparing a _eech._

& M. H. attends victorious cocoa party. She _histles_ "See the Conquering Hero come" accompanied on _a_ cup for the benefit of the company.

<div style="text-align:right">Signed & adopted M. K. M. & M. H.</div>

"Oo-er !"

Nothing whatever
to illustrate.

Smt

Both down in time. Sausages for breakfast at last! MKM in sheer gladness of heart has two.

<u>Varsity news</u>. MKM saw the Kat in the distance, but only gazed reproachfully at one who is so bad a correspondent.

We regret deeply that this the most important item in the page should be so meagre today. It is our misfortune rather than our fault.

No lunch news.

DMH went on the river for half an hour & came back & joined MKM in consultation with the Muses. MKM leaves her arduous duties to get ready tea party which she & M10 are giving to L.S. Function a great success, though RF & E.C.H who take upon themselves the duties of critic & reporter (outside the door) express their disgust anent the opening ceremony. LS obviously bucked & proffers tentatively a general invitation for some day in the dim future.

MKM calls on Lettuce, but Edie announces that she is engaged.

Dinner. DMH begins by playing the Portman so gets very behind in the meat, & has to put up with cold vegetables. M.K.M sits at LD's table which is entertained by the unfailing wit and vivacity of EAP. It is decided that "the King" in private life does not look a gentleman. Also this postulate:— every "Bertie" is an ugly man, but not every ugly man is a Bertie.

DMH attends Sociable, & dances like mad. Feels a different woman in consequence. MKM asserts that no difference is yet apparent. She hopes manifestation of the conversion is still forthcoming. Signed & adopted DMH. & M.K.H.

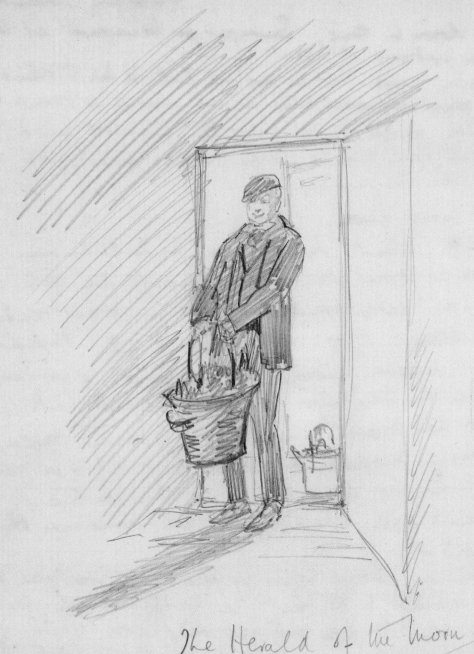

The Herald of the Morn —

neither down in time. D. M. H. is awakened out of a
deep sleep by the sound of the coal box being
clanked down and her astonished eyes open
to see the leery Stephens close the door. This
horrible spectacle has haunted her all day,
so that she has not been her usual bright
self. The Lady of the House tells us that Mr
Stephens was equally upset "He is so
very particular to knock at the door." We
know of another side of Mr Stephens.

Varsity News. M. K. M meets a Bertie who comes
under the category mentioned yesterday.

Lunch News. Both play in a most
miserable game of Hockey. D. M. H. deplores
her public spirit & gratuitous self denial which
prevented her going to the Irish Plays.

Scratch tea with Molly. Gums discussed &
renounced.

M. H. attends Slade Lecture on Rembrandt.
M. K. M. goes to the Union. The curly headed
lad opens debate "That this House would regret
the identification of the Conservative Party with Mr Chamber-
lain's fiscal proposals" The Pride of all the Beauchamps
replies with much force & abundant wit. The
shy librarian speaks third and an oddity from
Christchurch fourth. The missing link or Ld Hugh Cecil
the last speaker on paper suggests that the hon'ble
proposer can still afford to learn wisdom.

Signed & adopted M. K. M. Bruce

The Sub Librarian
Explains.

Sketches from the
P.O.P's Lecture

Prof— de Sel. sets the fashion for Oxford officials

The Earwig
Caught—!!

Both down in time —

<u>Varsity News</u>. MKM has nothing to record.

DMtt on her return from Prof. N— at 10 o'clock, had the supreme pleasure of seeing the "Earwig" eating its lunch, or rather we should say drinking — One touch of nature makes the whole world kin —

No lunch News.

DMtt has a lively single with the Hockey captain of St Hilda's at the Central Club. She has snatched tea with Gertrude, and goes like everyone else to the Prof's Lecture on Aspects of Modern Poetry. Prof de B— has in everyone's opinion excelled all former triumphs. The only dissenting voice is Hannah's — she thinks he spoke too philosophically and not poetically enough. She would —

Some humours at the Lecture seeing that all Oxford was there. MKM sits in such a position that she could see Prof de Sel, A L, Bishop Hutchinson, Canon Biggs, Prof Bradley, Higgs of Balliol, Prof Caird, and other unknown Big-wigs, to say nothing of all the other members of the University. Prof de Sel's undergraduate companions watch him narrowly, and take their cue by his expression. So are the best imitated! At the end of the Lecture H M P addressed by female half his size, who asks if he attended the Irish Plays. H M P swelling with remembrance of speeches before the mighty civilly states "Er, no rather occupied yesterday"! "
worramac. ready to come but late to go

Signed — adopted DMtt & M.K.M.

The Male Spectator

Both down in time. Both driven to High at Breakfast.
Sue not in a conversational mood.

‾versity News. No news of any description owing fact
‾at Saturday morning is spent exclusively with
‾e Muses. No lectures so no humour; No Queens
‾lane anp so no oddities.

› Lunch News.

D. M. H. has the proud position as centre
forward in the St Hugh's match versus
Somerville. She manages very well des-
-pite the enormous difficulties of playing
against the ex. captain of the United.
The chief feature of the match figured
among the spectators. A gigantic
male form made his appearance on the
field and shouted lustily for St Hugh's.
Somerville evidently thought this bad
taste; but St Hugh's was greatly bucked.
Tea with E. A. P. where we parted with our
scalps. D. M. H quotes Charles Fox in the process.
D. M. H goes to Senior Common Room Party.
Some excellent Music and abundant humour.
From fear of rivalling the bumptiousness of
the "Oxford Magazine" we refrain from criticism
of any kind. We only remark that St Hugh's has
taken a new motto "If it weren't for the Plough
The fat ox would go slow." (Sussex Song)
signed + adopted M. K. Macdona.

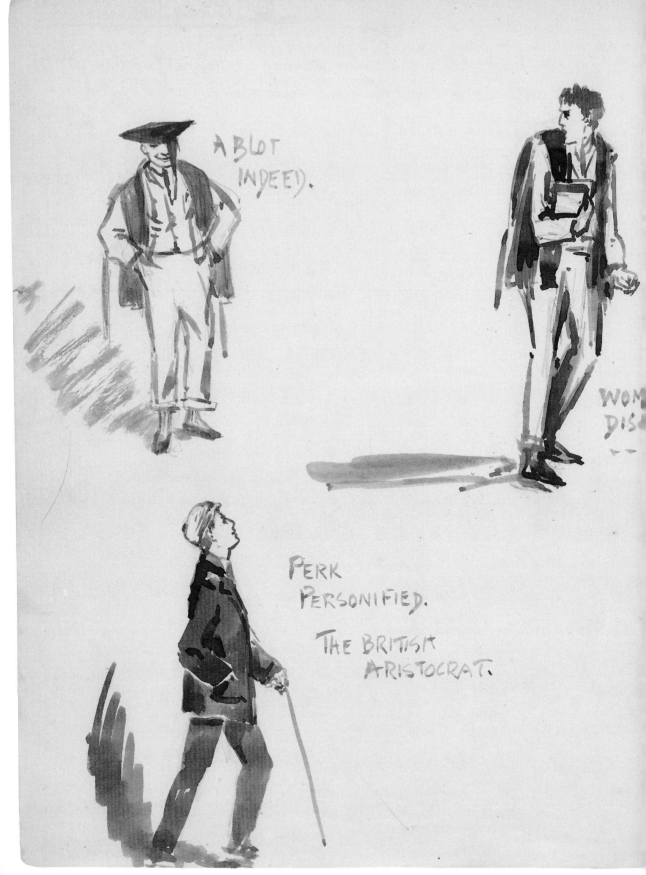

A BLOT
INDEED).

WOM
DIS

PERK
PERSONIFIED.

THE BRITISH
ARISTOCRAT.

Monday November 27

Both down in time. Interesting breakfast in high quarters. KM 'found' indulging in some of her raciest Parliamentary isms 'and political epithets this early in the day and week. We got to mention that we both rose betimes and served the University.

<u>Varsity Intelligence</u>. MA today is the lucky dog. She saw our honourable friend crossing the High with perky air, a perky stick & perky cap. We wonder whether such aggressive perkiness is a symbol of success at the poll, but this is only a conjecture.

Now for Shelley. The little hog "has his exits & his entrances", but today he certainly had his exit, for he left Prof. N's lecture crowned with a mortar-board, looking too watchful for words as per picture. Varsity news seems to have accumulated today. MKM sees "the-only-man-in-Balliol-worth-knowing" (she may not be so exclusive tomorrow) approach Mr A! to ask intelligent question with an important smile & charming air. However, a girl must likewise reaches Mr A first, whereupon the aforementioned only-m.-i.-B.-w.-k. turns on his heel, & stalks down the Hall, baffled & disgusted.

A distinctly humorous, but very enjoyable tea. RF entertains friend from Eastbourne, & we are hired out as conversationalists. Such is our success that we are voted "charming girls". We are both distinctly typical throughout, but eat a good tea from excellent November. Mr. 10 returns to our room where we all three discuss theatrical complications loudly denouncing & ridiculing the O.P. Small measured tones from & von V's room convulse us with horror. The O.P. has such excellent ... MKM bravely investigates the room & all are reassured the danger is nil. M10 & DMH have not felt the same women since but MKM abominably callous. Signed & adopted DMH. MKM.

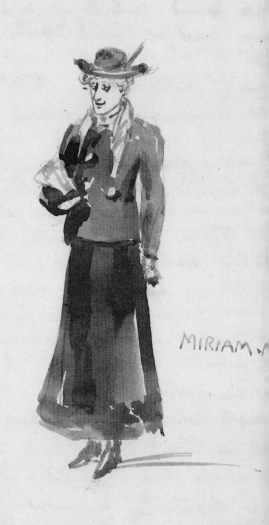

MIRIAM

DmH attends our morning diurnal devotions — MKM far
too busy, what with going Balliol Breakfast. We feel that
this great event must occupy some space in the diary.
First as to MKM — She sits beside a man who can only
talk politics. This "Seeley" points out is very great
luck, for MKM, she says, can talk on nothing else ! (MKM
is very bucked at the criticism) The man was on the whole
satisfactory, safe for one blemish in his judgment — He
considers the Hon H a "prosy in parts" though he kindly adds
that he is witty sometimes. These young Balliol men must
be taught a thing or two. And now we come to
"Miriam's Conquest." MH we feel has met her Fate —
 She is overheard remarking to her
Companion "I don't know what I should have done
without you", and seems altogether smitten — We
shall watch the sequel with interest, for Dixon was
his name o !

Varsity news. Rather a scene at Prof N's lecture, between
RF and DmH versus undergraduates, anent
position of Blackboard. MKM feels she need not
add any more Varsity tit-bits after her Balliol
experiences —
 DmH teas with P de B BC
 MKM with the fish — no humour —

An exciting dramatic meeting with the V.P.
Absurd suggestions & hopeless plans — nothing
settled and everything proposed from English
drama & fiction — MO in accordance with
expectation discusses the feasibility of performing
John Inglesant or Lorna Doone — "O for a
muse of fire that would ascend the highest heaven of
invention" as Bill would say — Signed & adopted DmH + M.K.M.

A hurried sketch of the new [...]
at breakf[...]

Both down in time. Bacon for breakfast, badly cooked.
M.K.M. sits in the seat of the mighty, the V.P. being at the
high. It is gratuitous to say that she filled her place
with grace and majesty.

rsity Intelligence.　None.　Such our luck.

No lunch News.

Both spend afternoon with the Muses till advent
of G.N.S. who babbles like the brook that goes
on for ever.

Tea with G.C.H. to meet Miss B.H.　She is a great
success.　E.A.P. surpassed herself, while
M.K.M. & D.M.H aired their French witticisms.
We cannot help thinking of Monsieur Beaucaire
who would assuredly have sent his thanks
up to Heaven with ours that we were not
born Frenchmen.——— M.K.M. remarks that
small amount of bread and butter merely
means that it is an hors d'oeuvre, seized with
sudden misgiving she changes it to chef d'oeuvre
to intense delight of assembly. D. M. H
improves occasion by remarking that a witty
friend of hers translated hors d'oeuvre by
"bar horse" The company are politely amused
until hors de combat is suggested as giving
more point to the story.　Inspite of these
little failures the "feast of reason and the
flow of soul" were a perfect treat. We all
ate too much but thoroughly enjoyed ourselves.
D. M. H is given a ticket to hear M. Mesunio songs she
is very enthusiastic on her return. Signed + adopted M.K.M & D.M.H.

Union Attitudes

Mother's darling
Father's joy
Brother's pride
Sister's toy —
 But n

Ch. Ch. Oddity —

Merton Professor.
Rale Oirish

Junior
Treasurer
from the
Far East

Both down in time — DMH drew matters rather fine by only waking at 10 minutes to eight. However with a rush and a bustle we were down in time — worried eggs for breakfast. MKM finding the UP's seat occupied assumes today the rôle of SS at breakfast. (Grace and majesty as before — see yesterday)

Varsity News. No morning items. Evening story recorded below.

Hussey episode — Scene. Queens Lane — Dramatis Personae. DMH. RF. and Hussey —

Time — 1 o'clock p. m.

DMH & RF seet Hussey approaching on side walk and both mentally resolve not to be ousted from her position on the pavement. Result — Standstill of RF & Hussey against the wall. We consider this the height of chitness, more especially as R.F had to give way —

Hockey match against LMH II. We won 5-0. Huge hortlings — This is recorded as an historical event that later generations may know that now we play LMH II so B. It is since the advent of DMH & GCH that the team has been so successful, though there is no pride of this whatsoever. MKM attends uproarious "hockey" Hall Tea, where she facetiously nicknames Peggy the 6th forward — DMH takes tea with MC & cheers the higher Local students in their unhappy lot.

We must not forget to mention that this morning MKM uchased surreptitiously (breathe it low) THE VARSITY !! is really respectable weekly will find in us constant of patrons, that is if our means will rise to it — (It costs 1d) And now we come to the Union — DMH went — The motion s of no interest, neither are the speakers, but one of the officers and, we grieve to say, defeated candidate in the Presidency was altogether charming. He came, solely on the purpose of clapping the result of the Polling, and name of the President Elect — more of the latter anon. Junior secures refuses to takes steps in some matter.

our honourable friend — What ? not even a passent —

.T. no sir, pas du tout. And this is called "depressing "wit" signed & adopted DMH. M.K.M.

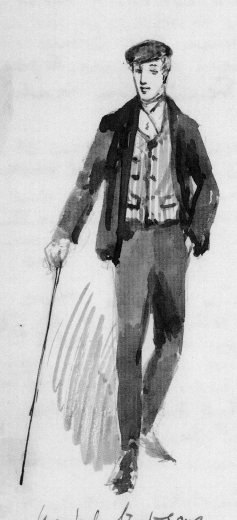

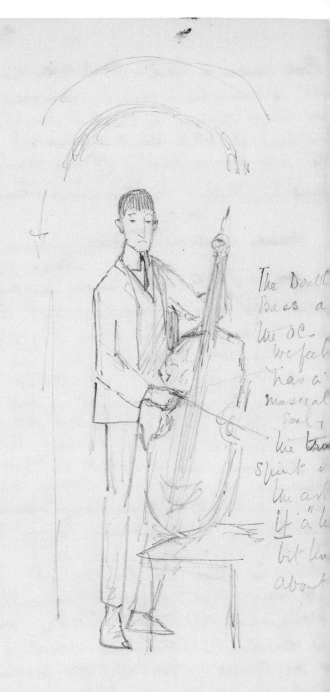

We feel that some
Explanation of this
horsey attire is needed.
We suppose the
Gentleman hunts.

The Double
Bass a
the oc—
we feel
has a
musical
soul
the tra
spirit
the ar
if a l
bit lu
about

Both down in time. M.K.M, D.M.H, & E.A.P. have semi-political meeting after Prayers. This makes them late for breakfast and they find literally nothing to eat.

Varsity News. M.K.M. cut lecture and consequently she has 0 news to record. But D.M.H. has astounding luck - The Pride of all the Beauchamps again crossed her path, looking, she is sorry to say, horsey and common but nevertheless charming. (see picture)

Quite a humourous occurrence at close of Prof. N's lecture. Undergraduates thinking it time to go home to lunch try all the Varsity tricks to shew Prof N. their opinions. Their efforts were efficacious but impolite. - Huge tappings of feet, two change places with great bustlings, while back row led by Shelley laugh and talk gaily in strident tones.

D.M.H and K.M return via town in order to avoid Hussey in Queen's lane. We own this is cowardly but perhaps advisable. Peace at any price ! "To quote the Great."

Afternoon spent revising and completing the back pages of this historic work. In spite of large "Engaged" on door we feel qualms every time a footstep passes the door.

Pleasant Quartette take tea at O.C. Lv.V. D.M.H, E.C.H & M.K.M. Lv.V. pays the shot; we eat the grub & "dare unchaperoned to jazz" and also find some humour in the band, especially the double bass.

Varsity Opposition meeting summoned by E.A. Philips (M.-P. Member for Paddington) M. Otley elected leader. Great Ignoramus meeting under presidency of M.K.M. F.T. gains prize for "miscellaneous guessing."

Signed & adopted M.K.M

Monday Dec: 4ᵗʰ

Both down in time. Breakfast conversation entirely turns on the first session of St Hugh's Parliament to be held in the evening.

...rsity News. D.M.H has no luck although she visits the "West End" of this university-city for the purpose of attending a lecture. M.K.M. is warned by a telegram to avoid her lecture at Queen's. She does so with a pleasure which is not complimentary to the Lecturer.

...Lunch News.

D.M.H. spends the afternoon in a becoming fashion with congenial friends at the Piano. M.K.M. broods over her coming speeches & wishes that she had never come to S.H.H.

Both take tea with Mrs M. Owing to the short notice the grub is not up to the usual, but an engaging black kitten provides magnificent entertainment and makes up for any omissions in the food line.

...e last meeting of the H.T.S. for Michaelmas term takes place in R.F.'s room. M.I.O is allowed to attend chooses a seat conveniently near the Chocolate biscuits, M.K.M. however insists on her vacating this place as she too is fond of the aforesaid biscuits.

...Hugh's Parliament. The Speaker took the chair at 9.45. ...e Labour member for Battersea (otherwise our beloved D.M.H) asked a difficult question of the member who had undertaken the Presidency of the Board of Education, in such a way that the House was led to think that the Labour member was no...imitation. The reply of the minister for Education was not conspicuous for its lucidity. Other questions of less importance were answered by the members of the government with varying success. The Athens Bill was introduced by the Home Secretary, and passed its second reading despite the able speech of the member for South Paddington. Signed & Adopted M.K.M.

The OSDS

a
libellous
portrait
of the
Hon Opp.

the Hon:
Prop-

Both down in time. A regular Parliamentary
meeting after breakfast to discuss last nights
proceedings. General amusement at the Minister of
Education.

Varsity News - The Scholar shows his ~~Tutor~~ Vicar round
Colleges, at least so MKM surmises when she
meets him in Merton Chapel in company with
a parson. Huge deference and opening of doors
on the part of the parson, patronising condescension
on the part of the Scholar (who is good looking-)

Lunch news - Dutt again assumes the rôle of VP.
MKM plays second fiddle in the SS's seat - Poor
lunch - Ugly meat and no puddings. Called away
in middle for Hall meeting to decide on Wedding
present for "Annie the Coeducated" who is marrying
an amorous chauffeur.

Dutt goes to reading of Paracelsus by Dr Pope
at the abode of Margaret Lucy Lee. The reading
satisfactory, in fact thrilling as Dr Pope knew Browning,
but hostess and tea eminently deplorable - MLL
breaks into a soliloquy on the ~~part~~ art of Dr P with
"I am sure Dr Pope we are all much obliged to you, and
now you must all come and have some tea "in her
brightest tones - "O woman! in thy hours of ease" - etc.

MKM has tea with F de B P BC - Provender good,
company poor.

OSDS Great Debate of the Term. MKM makes her
maiden speech. A great success - Dutt applauds
as "Egoistically" as possible, both hand and foot.
Melton Prop. ~~advocates~~ advocates Coeducation as a matrimonial
bargain - She would. MKM & MD are elected
as Treasurer & Secretary for next term - The Diary offers
congratulations. Jate goes over with. Signed Ludovika Dutt + M.K.M.

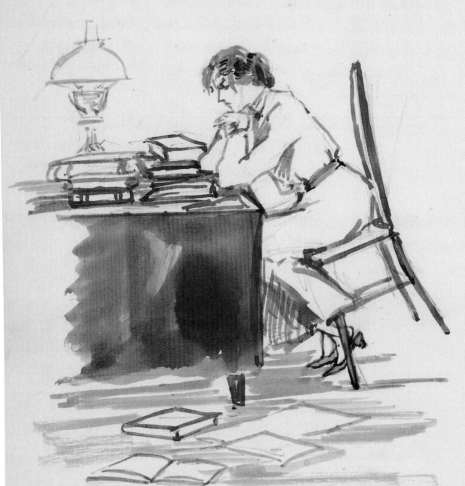

Unpalatable Umlauts.

Both down in time. Sausages, though not good ones
for breakfast. So are our fondest hopes most
often blighted.

__rsity News.__ D. M. H sees her musical friend. (For
portrait see Nov: 20ᵗʰ.) She also sees Hon H.
This is becoming such a daily occurrence that
there would be no need to record it but for the
fact that he was observed to be smoking a
cigar. N.B. He smokes "Mark that."
Prof. de Sel' horribly put out by finding corner
of page torn off. Great delight of men at lack
of words.
D. M. H spends a large part of the afternoon with
the Muses more especially the (un)palatable
__umbuts__. M. K. M. only spends short part of the
afternoon employed thus.
 A very humorous year tea. party & one of the
nicest we have had. The room was arranged
as for the a Christmas party by R. F. Only
crackers and holly were needed to complete
the analogy. At the risk of their reputation D. M. H
H & R. F take off other members of the Hall. Their
audience is delighted, but they themselves feel
nervous as to the sequel. D. M. H. takes the final
plunge with the "A type" and comes out with
clean hands "if a little bit knocked about".
M. M. gives tea to her colonial friend from Magdalen &
warns that it is not the thing to do well in 1ˢᵗ term
__Collections__. We quite agree with him.
 Signed & adopted M. K. M.

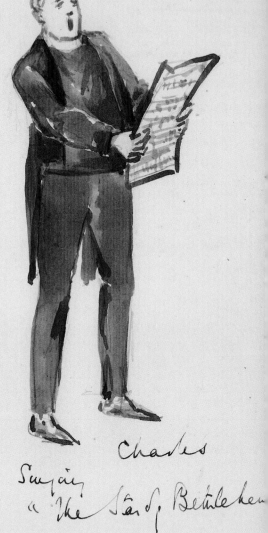

Charles

Singing
a "The Star of Bethlehem"

Thursday Dec 7th

Both down in time. Breakfast exceedingly dull — MKM sit at high. She is still away, and the VP is not a conversationalist in any form of the word. DMH collects bike excise.

~sity News Close of Herbert's last lecture marked by an ovation — the great man blushes to the roots of his hair and the joy of the girl students.

Lunch disturbed by Hall meeting — DMH gets no pudding. HH is feeling somewhat slighted by an impertinent proposal that it should play for a Challenge cup with St Hildas. Hockey match between No. 28 & No. 17. No.17 wins by one goal — Nice scratch tea DMH, MKM, GCH, RF, in fact, the Junior Common Room —

Evening Amusements — MKM dines with Mr. Armstrong in company with DJO, & RAH — Gleans a great deal of University intelligence of varying interest. She would! Among the items we learn that the 'Scholar's name is St----s, a name already used in the Diary in a different spirit, & with more or less unpleasant associations (See Nov. 23rd) so that L B----p was sent down, and that our noble head, the joy of Magdalen, is a half brother; etc etc ad lib.

DMH goes to most pateful Smoking Concert at St Johns. It doesn't sound very respectable, but the VP cast a cloak propriety over the proceedings' or rather over our presence there. DMH meets her old friend Charles, who tries to renew his Christian name acquaintance and also sings. We are advised to go at the end of the first part of the programme because you never know how rowdy they may get in the 2nd part but we were given a foretaste of what is to come by a Comic, not today music hall Song, illustrated by a fandango, and accompanied by 'some excellent whistling'. The VP is as pleased as punch & roars with laughter. DMH fancies she hasn't caught the word — liked home in very amateurish manner in the vest sister adopted DMH — MKM

Hilary Term. 1906

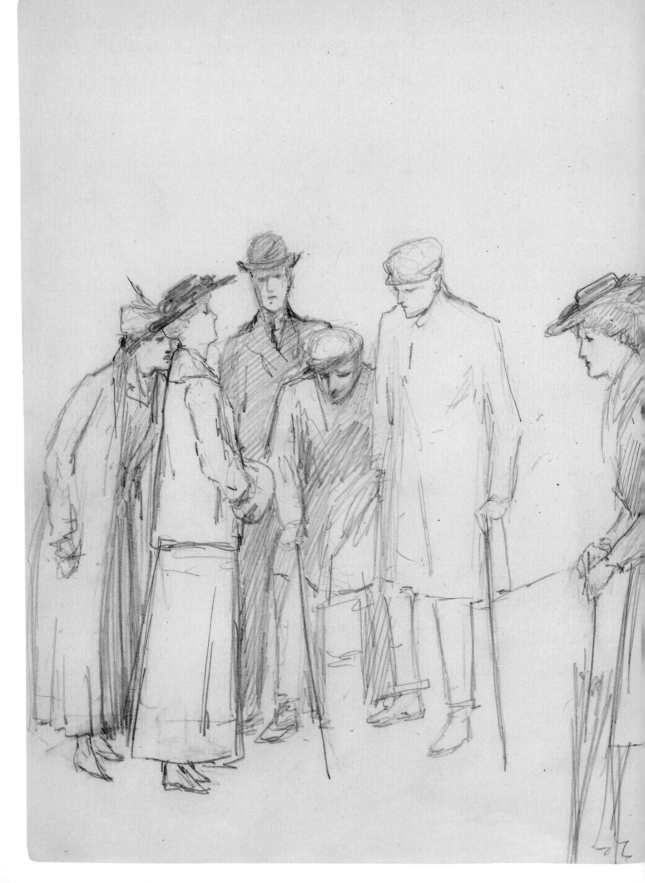

Both down in time. Very poor time at breakfast!
Worried Eggs; and those Cold.

<u>Varsity</u> news. We have not as yet sampled the "High."

After deep consideration we find there is <u>no</u> news
today, so will proceed to supply instead some
tit-bits from yesterday.

Smith "accompanied" by GCH & MAK wends her
way home from Cathedral after the shades of night
have fallen. As they turn into Norham Gardens
they are startled by a sudden "chink" and proceed
to search the ground for some yards round for any lost
treasure. In spite of the faint guiding beams of
gas lamp their efforts are fruitless. They therefore
"give up the struggle" and pass on. Hardly have they
proceeded five paces before another strange chink
resounds behind them. This time they are not to
be baffled, though in the dark. They are almost
on hands & knees grubbing in the mud, when they
hear a masculine voice behind saying "Can we
help you. Have you lost something?" While a
second ditto exclaims, lighting the pavement by his cigar
"Why, there's a sovereign on the path. I saw it distinctly!"
Great excitement & searching for matches. The moment
a match is lit each party looks at the other, three girls
& three men. The "sovereign" proves a halfpenny,
but the incident was distinctly an amusing one!

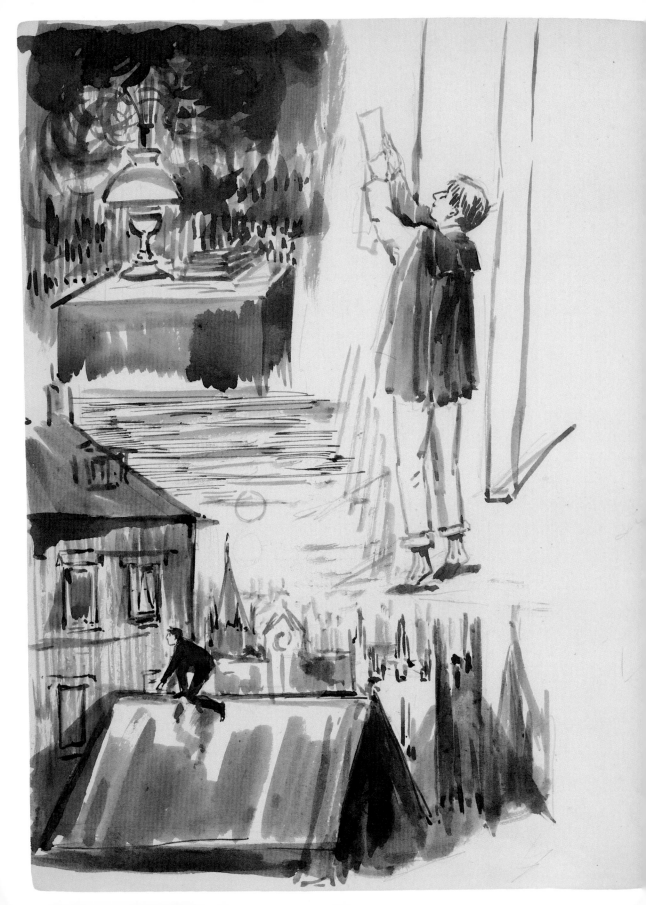

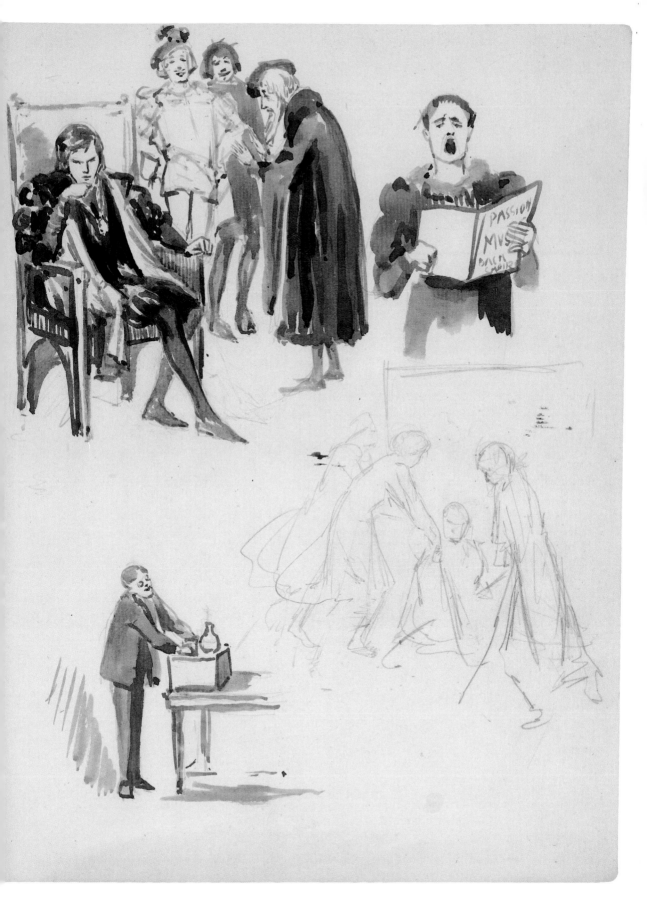

Summer Term 1906.

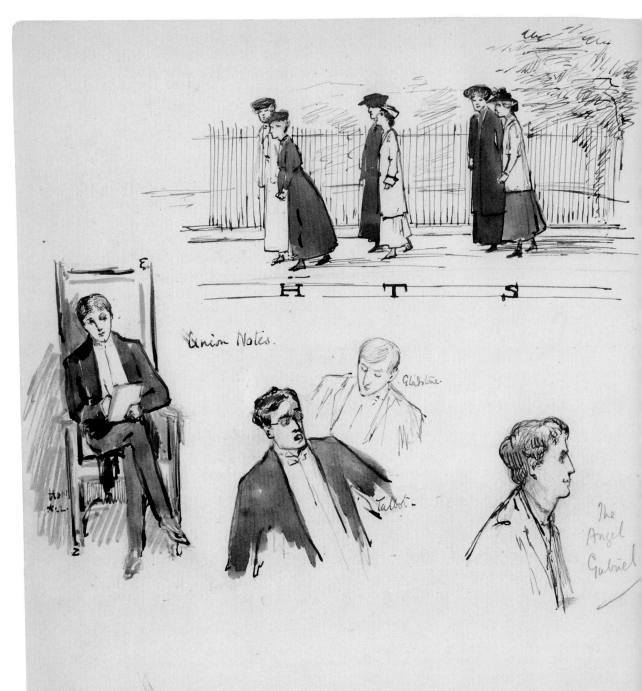

H T S

Union Notes.

Gladstone.

Talbot.

The Angel Gabriel

Friday

D.M.H. & M.K.M. attend lecture in the High School on Oxford in the eighteenth century. It was not the fact they were obliged to do so by Potter, or encouraged by Jourdain, or even that pictures being eighteenth century might be useful that made them thus eager to attend (of course not). It was because the lecturer was one Dr. Woods, father of a famous son renowned for Politics & Mountaineering. No resemblance can be traced between father & son or between M.H.W. & the Angel Gabriel, at all events now in art.

Notes for week ending April 28th 1906. Written on Ap. 26th

M.K.M find it necessary to state that owing to a startling development in application for work they are unable to keep this ... any more than once a week - They offer their condolences to you, O Reader, for all that you hereby miss -

The 1st event of importance this week was the inaugural Tour of the H.T.S. to the famous hamlet of Littlemore, which demanded inspection for three reasons. ①. The President's father received his first glimpse of knowledge there. ② The Uncle of our noble friend and colleague M.C was Rector there. ③ It is generally supposed that Cardinal Newman had something to do with the ... - The walk was enriched by constant change of companions, every possible combination of the Six members being tried with much success. Moreover we saw - (a) Shelley (tracked to his lair!) (b) University tennis. (c) An accident (d) A view. (e) a child sucking a broken china cup. etc etc. We concluded our Tour, the 7th! we hope, of many, in the President's room where we partook of a 10d tea - We are appalled by a threat from our noble President to double daily any contribution not paid before Sunday -

Tuesday uneventful -

Wednesday Year Tea party. First part without incident, but when tea had warmed the cockles of our hearts we entered on our anecdotage - Many were the tales told both profane & vulgar but they pleased us as only questionable jokes ever can - We present the palms of victory to M.I.L & M.C. two promising "raconteuses"! Honourable mention to ..., our genial hostess, for her "Dives" story.

Thursday.

An uneventful day till night drew nigh, and then we hied us to the Union on the 1st debate under Presidency of one whose name is not unknown to a Reader of these pages. M.K.M takes careful note of how a President should behave, look, speak & sit - She is highly satisfied with the model of tonight. A splendid debate on the Education Bill especially from an episcopal point of view - House crowded top & bottom, but by dint of much chivvying and many hints to the uninitiated we get a good seat after all.

Signed & adopted. O.M.H. M.K.M.

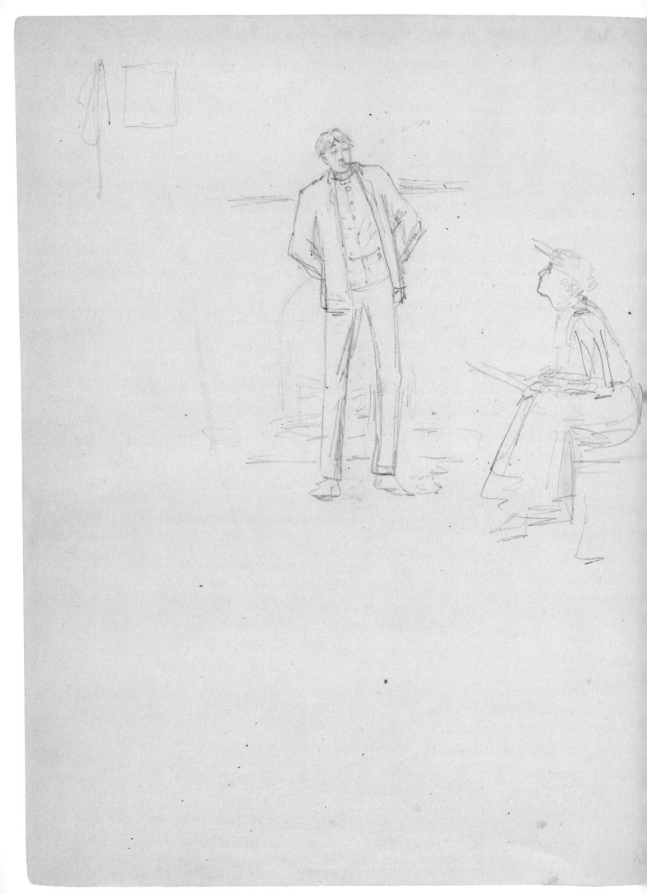

Notes for week ending May 8th written on May 2nd

day

The 2nd tour of the H.T.S. covered fewer miles & evoked less interest — we went to the Museum. Each member did her best an object of interest in the whole show — Architectural beauty nil, historical importance scanty, literary & artistic value non est, ∴ the spot does not fill the regulations of the Society — Having been there some time, our patience fizzled out & we returned home to tea with N.C. our retired but still interested member.

Tuesday

A memorable day on many points. t.M.H. & R.F. have their first coachings with the Pixie. The nature of R.F.'s coaching may be judged by the fact that she has converted the pet name of Pixie into that of the Beast. t.M.H. is relegated with her client Dryden to the Kingdom of fools. Both R.F. & feel in a somewhat headless condition having had their part of the anatomy bitten off by A.J.C.

In this severely damaged state they proceed with nearly all the Hall ~~to~~ to a Churchman's protest against the Education Bill in the Town Hall. The speeches of the Bishop of Oxford, Sir William Anson and Lord Hugh Cecil were approved by the Junior Common Room & the President of the Union whose presence was conspicuous by its shirt front. On the vote of condemnation being put to the ~~motion~~ meeting one futile dissentient voice was heard to complain "down with them." Nobody knew what, but that didn't matter. Jelly-pore.

Thursday Sharp Practice — P.B.C. a good President. Motion "that a democracy without an aristocracy is a bane to any country." debated quite warmly but without logical reference to the subject. M.K. makes her maiden speech with perfect sangfroid, though without charm in delivery & manner, or wit and reason in matter.

Notes for week ending May 12th written on May 10th

Sunday. Killed off so-called Gardner — + MPP & LFT.

Monday. ATS migrates to St Peter's in the East, and Christ Church Cathedral. Baffled in attempts to explore the crypt, but very interested in architecture carefully indicated by MKM who surreptitiously consulted Alden's Guide behind every pillar. We took in her taradiddles about Christ Church like lambs, for she was the acknowledged guide —

Pleased with invitation from Mrs M to view the boats "next week —

Tuesday. Tea with Mrs M. Clinched the bargain anent "boats" — S.M.H. has mighty struggle with 'W.W.' for tennis championship & proves victorious in the end.

Dinner. During this meal Sue casts a bombshell among us — St Hugh's is going to give a party on June 9th to all & some in Oxford. We may all ask visitors with the exception of other 'shes'! But the whole point of the announcement is this — the programme is to consist of music & dancing. We shudder to think of the flurry, 'flurry', hurry & worry undergone by all till the show is safely past, especially in the case of Sue, Nellie & Rena. Most of Hall attend Sociable, including W.H. a new arrival, whose lengthy toilette of an hour and a half did not produce a worthy result — Plain, prim, and pink —

Wednesday. Don't trots off to Balliol breakfast with Ludmilla. Has a distinctly thin time herself, but watches Ludmilla holding a small levée of admiring undergrads with some amusement. Sat by Professor Wrinkley, head of University for men & women in Toronto. Mr. Dehn (see portrait on Nov. 16th) inspected closely — Mrs C a very humorous old woman.

MKM visits her pet Thursday resort at 8 precisely, in the neighbourhood of St Michael's Bell — Some amusement evoked by artistic efforts of librarian & junior Treasurer to draw the President. Hon H, awfully tricked, insists on signing the portraits.

Notes for Week beginning May 12th written on May 14th

Saturday. A frivolous day on the whole. MKM begins early by
going to breakfast at Queens. Gratuitous to mention that
Mary & Rhoda were late but MKM paces the Quad with
the Senior Bursar of Queen's & is quite in her element—
SMH spends afternoon on the River with two of our revered
old members. Being a "glorious" afternoon they got to the
"Barepitts" and were in consequence rather late home
for the event of the day, viz. an "undergraduate tea" in
the garden of "the House." The hostesses L.V.V. & G.W.W were
charming, the former swathed like an Indian priestess
in a white liberty gauze scarf. The men were five in
number, the girls seven. And all went merry as a
marriage bell. They stayed till nearly six thirty and then
departed most reluctant— We have all agreed it shall not
be "last" of this type of entertainment.

"The R.O.M (see above) honoured our room at 9-30—
after partaking of tea & biscuits the party which was
a large one resorted to ye ancient gayme of "dumb
cramboe". In the attempts to find a word to rhyme
with "Teak"* R.F found as the little vile Blot (see Nov. 21)
I should mention as really successful (no offence meant
can be took!) free & easy use made of Ludmilla's very
best "eights" hats while 2 pokers and Molly's evening
wrapper completed the stage properties— Party apparently
appreciated by all except those who listened from
the other House (markedly C.H)

day. DmH & GCH make most successful call on
Cobb, & reap the invitation they went out to
glean—

P. To.

Teak'

...day. This was the day we slogged.

...day. A "dernier dull day" till evening hours draw nigh, then MKM with much dignity & GCH's gold chain assumes the rôle of President of the O.S.D.S. (This was not the complete costume of course) Animated discussion on the Education Bill; the Vampire brought down the House.

...nesday. DMH spends an uneasy morning weighed down by the tormenting terrors of the Tennis tea, and the trying task of choosing champion's ties. We grieve to say that DMH has become even more mumpy than before, and are to be treated accordingly, being allowed the run of the garden, but not admittance to the house. We grieve to say that Somerville worsted us, we being nettled by the net-play of the jumping Jackson, & the hard hits of the terrible Terry. However St Hugh's defeated the first pair of the Oxford six in spite of the fact that it plays twice a week with the Varsity champions. DMH forms one of a party of six friends to attend the theatre. Supper of poached eggs at 6·45, scuttled out of the front door with stealth at 7., reached theatre at 7·15, got in early door by paying your extra sixpence, saw Martin Harvey it is true, but never a sign of a chaperon! The Breed of the Treshams an admirable play.

...day. MKM Balliol-breakfasts, and chooses her subject for conversation as before. See Nov. 28th

...day. We attend the conferring of honorary degree on 5 heathen Chinese. The Vice-Chancellor makes one or two Latin blurs; while one Chinee utterly refuses to shake hands with the V.C; to the intense delight of the Varsity in the top gallery, he at last submits to take the outstretched paw.
In the afternoon we go with Mrs Mann & Hugh to the Boat...

The event of the afternoon for us, was not whether Univ was bumped or whether Magdalen rowed over but that we had tea at the Union & what more had it in the debating Hall - We ask you, fair Reader, to imagine us examining the pictures & sampling the President's chair - It was the last place in which to have tea, but we enjoyed ourselves. We learn from Hugh that the proper name for Christ Church is "the place just opposite the Post Office". Such is fame.

Saturday Dorothy went to Eights & kept her eyes open.

Monday Dorothy sickened for mumps (which have not developed yet)

Tuesday Dorothy went to first part of Eights & owing to the Pixie's carelessness missed the second part.

Wednesday. A thrilling not to say frivolous day. Having carefully culled Miss Simpson as a chaperon we proceed to the boats in a carriage escorted by C.J.B.S. (for parentage see) We procure front-seats on Magdalen Barge and are introduced to a Rhodes Scholar, the first of the species we have met. We dispel any lingering qualms that he has had about swimming across & in the end have the pleasure of seeing him perform this feat without drowning. A patchful afternoon interrupted though not marred by the rain. Besides the two bumping races we have the pleasure of seeing Magdalen's aquatic sports.

The Cox we grieve to say, was treated disrespectfully. Smart & elated with victory, he emerges from the Barge only to seized on either side & thrust into the water. Joke fully appreciated by all but the Cox — His blazer ruined.

Keble Concert concludes Eights week festivities. Great success, all but the Exit.

The joy of this very humorous day much damped by the knowledge that our sister Rosalind is again indisposed; this time German Measles has her in its clutches. The fell disease has also laid Rhona Lane low. The whole Hall lies in fear of swelling the German Band.

MICHAELMAS TERM 1906

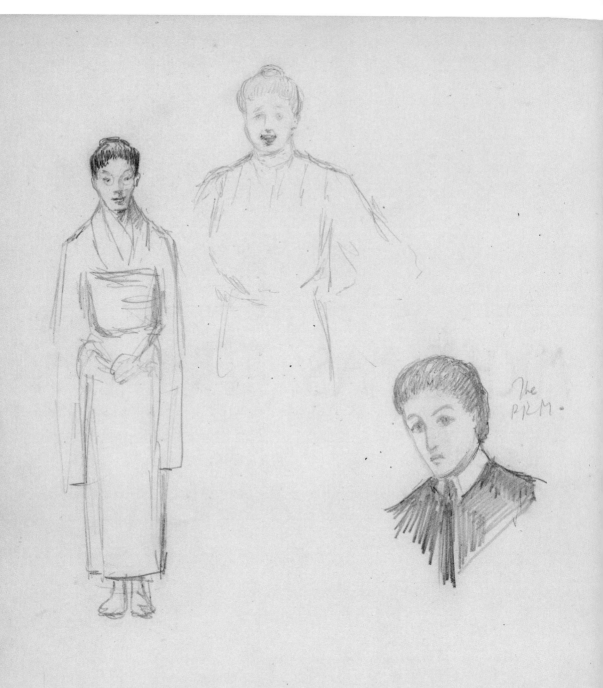

The
P.R.M.

Oct. 13th was our Opening Day. It found us still in the same room & same clothes — S M H greets I7 K M at the beginning of her last strenuous year with the cheering remark "I've done all my work". It seemed a pity that time & money was to be wasted on a 3rd year. Far from this being the case with us, we are at liberty to state that these revered walls will contain her for yet another year more. Dreams of fourth year business overwhelm us — She Nellie & Lena just the same after 3½ months parting from us —

 Time cannot alter them nor custom stale
 "Their infinite variety"
 As the Poet hath it —

Despite alarming rumours to the contrary we found the Lady of the House still wields (with Sue) her temporal sway. New stair carpets —

Freshers.

① 1st & foremost we have among us a Russian Princess, who by her uproarious loquacity & bursting sense of humour already rules the household. She has already immortalised the homely mortarboard by terming it a "quadrangle", and shocked the Varsity by reference to its members as "boys" in loud & familiar tones — Her appearance is taut, and her chief vice unpunctuality —

② An untitled Jap of mouselike propensities and uncertain age. Her evening national dress is a source of great interest to the Hall —

③ A Pre Raphaelite model of good brains & shy manners — Yet to be understood, but infinite possibilities —

④ A penny bun — (A High school girl of the last type!) whose currants are just appearing

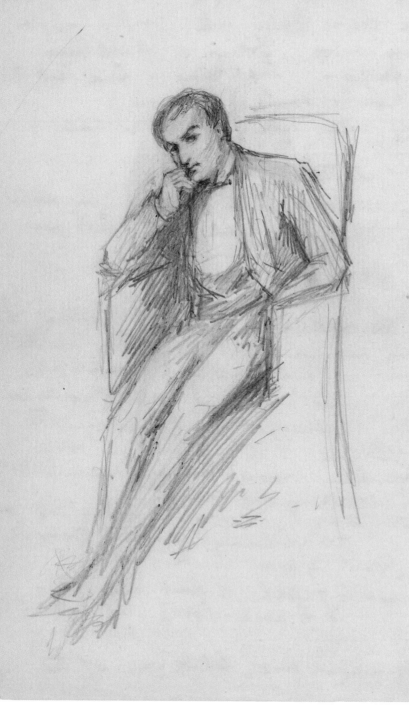

This little brute & the P R M bracketed together make a nice pair.

. A well meaning student of the English School - Too young & toothy - Tolerable Innoffensive but dull.

. Copartner of the above - At present an unknown quantity.

Two women who can only just be tolerated at present. Time, perhaps, will reveal their better qualities - We will say no more.

Uriah Heap - a myth -

<u>November 9th</u>

As there is little to record we think it advisable to mention how & here who are new coaches are and what they are like. Dorothy's must be dealt with first for he is the famous Prof de Sel already mentioned unfamiliarly in these pages. (see Nov: 8th 1905) Now we are able to speak of him on first hand knowledge and will implicitly state (1) That he is not an ogre as some have falsely led us to believe.
 (2) That he is as like Napoleon as ever & this D. M. A can testify, she having gone into the matter thoroughly.
 (3) That he has shewn considerable discernment, in that he has asked D. M. A & M. K. to dinner whereas former renowned pupils have had to be content with tea or at most lunch. Of the dinner anon.

M.K.H's coach is less interesting both from the point of view of physiognomy and renown. Suffice it to say that he is young, but blue eyed & long haired and is chiefly remarkable for his affection for Plato. Our advice to him would be to dwell upon the recommendation contained in the title of Haydn's famous song "My Mother bids me bind my hair".

November 16th 06

15th MK & DmH attend dinner at Prof de Sél's. Four undergrads to two girls — a good proportion! Prof de Sel & his wife charming, dinner good, conversation tripping — MK honoured by intercourse with the great during dinner, DmH afterwards. The latter treated as an artist, fearfully bucked in consequence.
 A HUGE SUCCESS !

A few hours after the above event this landing of No 28 awakened from sweet & dreamless slumber by a catastrophe. First of all the sound of loud babblings are heard without by MK M who leaps out of bed at once. DmH shaking off the bonds of sleep — but slowly hears sounds of an excited Princess, and sharp commands on the part of MK M to "bring a sponge". DmH is filled with dreary imaginings that someone is hurt, but is relieved by MK M's utterance to say that the Princess's room is on fire !

MKm it appears has been very on-the-spot and has taken all management of affairs into her own hands, dashing through suffocating fumes at the risk of life itself to open the window. DMH later on enters (having spent some time vaguely searching for a dressing gown) to find a really amusing scene both from a comic & psychological point of view.

Lena & her sister are both there, scared as kittens, with their hair in plaits & in nightgowns. Being just useless. Ludmilla, pale & calm, with blue robe swathed majestically, wearing the air of an aristocrat awaiting a revolution. The Princess, wrapt in a blanket, bubbling, giggling, joking, talking incessantly, finding the whole affair one large gibe.

Finally MKm the personification of "fush", directing operations, with a "Bring more water ha!" sort of air. DMH a spectator, who kept her eyes open.

To this enter

15t The Lady of the House & her Satellite — the former clothed in a magnificent red dressing gown. We feel that the opportunity for displaying such a treasure was one in a hundred. Satellite in morning dress. "What as bin 'appenin 'ere" are the tragic words of her ladyships opening speech, & we feel that the situation is at last realized when she ejaculates "Ridiklus!!"

2nd Mamma — tall, gaunt, in a coat &

Shirt, entering rather like the Ghost in Hamlet –.
Stoked & pressed out by daughters –

The conflagration seems to have been started by
the Princess chucking her bolster from the bed
in a momentary fit of ire, & it falling
just in front of a fiery furnace such as would
have amazed Nebuchadnezzar himself –

The smell was, at the time, the foulest on record,
and has hardly yet departed –

<div align="right">Nov: 24<u>ᵗ</u></div>

17ᵗ: At a party at Mansfield M.K.M. hears the
following story —— Siamese prince at Balliol
succeeds in passing "Smalls". He cables home
as follows – " Rejoice with me for I have passed
"Smalls." His delighted parent cables in
reply – " we do rejoice, fourteen noble youths
have been sacrificed". A propos of the
same story M.K.M. learns that a man
at Hertford has been rewarded by his father
with a Motor car for passing the same difficult
Examination – The Versity is trying to solve the problem
as to his scale of rewards for Mods & Finals.

22ⁿᵈ In Company with a few of the
chosen to MH & MKM repair to M.AK's 21ˢᵗ birthday
fête. The Study transmogrified for this occasion
only. While guests partaking of ~~absolutely~~ burnt
Cocoa are absolutely uncalled, for though & kindly
received entertainment is supplied by & MH & RF.

This is followed by an authorised variety programme in which the performers were practically chosen by lottery. E.W.P. led off with a comic song O' Flanagan's band accompanied feelingly by D.M.H on the table. I.C.H followed with a Highland fling skilfully performed over the fire irons & still continued, as if on her native heath, long after the fire irons had been kicked away. Molly & Rhona with a distinct shirking from responsibility executed an unorthodox & material cake walk. A recitation furtively rendered by D.M.H. A soul stirring scene from "the Gipsy's last curse" by two other members. (Stage properties an overturned chair & a hockey stick.) & an impersonation by M.O completed an excellent programme.

The company next proceeded to Dumb Crambo — Some of the best remembered items are —

1. Play scene from Hamlet —. Smile — Audience of that D.M.H's cast of features meant for Hamlet.

2. Adam & Eve & the Serpent — Smile — LF T Eve to the life.

But we also numbered among our repertoire Trial scene Merchant of Venice, Cromwell's dismissal of Parliament & the Egyptian Promenade (Nile.)

Atalanta is a good sort at heart, but somewhat spoilt by an unfortunate manner. In her appearance she is of medium height, with dark hair always well dressed. Her complexion is sallow, her eyes dark. Her eyebrows wear the inquiring expression that betokens a search after virtue knowledge. The worst thing about Atalanta is her bursting speech, over which she seems to have no controle, and which seems to suggest a hot & haughty temperament. She is characterised by great application to anything she lays her hand to, especially work overwh. She grinds by day & night. She appreciates a good story, and has a distinct sense of humour, but does not as yet show signs of being very interested in herself.

Lucy has little to attract the casual acquain-
tance & less to interest those whom fate
has thrown more often across her path. This
does not prevent her from being a worthy
person especially in her own estimation &
does not detract from her goodness of heart ~~or~~
~~causes her to take pity on those unfortunate~~
~~beings who are not often~~ This last mentioned
virtue causes her to take pity on those unfor-
tunate persons who have had little access to her
person & to spare them some precious
moments of in which to enjoy her company
alone — Lucy is profuse in her
hospitality & a great authority on etiquette [1]
a gentle reprover of the erring & an
unfailing encourager of the weak. Her
conversational powers are not ~~exhau~~
extensive, but she is not ~~a~~ bad listener, &
knows well how to ~~hold her tongue & be silent~~
shuts appreciatively & hold her tongue —

Her figure is fat & ungainly, but she is
quite good at games and if it weren't she
thought herself better than she is ~~in~~ this
direction her achievement would be more
universally approved.

She is a gossip.

Nausicaa is a maid whose great aim is to appear the leader of her clan. She is both small & uncomely, she wears her hair in varying fashions each worse than the last, her

choice of hats, especially tamoshanter's is not good, neither does she walk with an elegant gait. Her scholastic attainments are not to be despised, but she takes good care that you shall never forget it, by her patronising & easy manners. Be it here remarked that though an intelligent woman she has not the gift of good reading, & graduces to a state of exasperation her unfortunate listeners. She makes it her mission to draw out any latent virtue in her victims. Her voice is grating & whining. She wears a constant smile — and she is ever engaged in pushing into the conversations of others — while her powers of debating or shall we say argument are only waiting to be developed. —

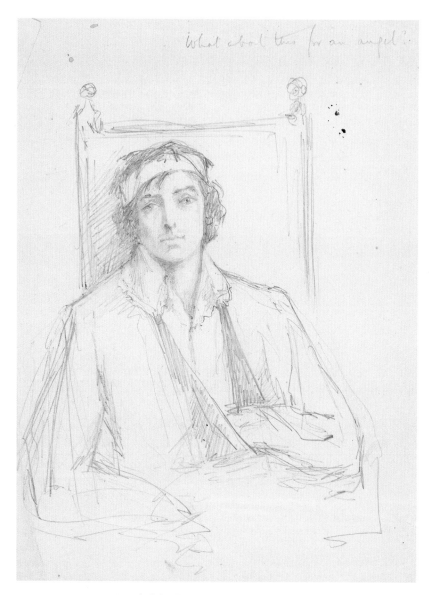

Detached sketch: 'What about this for an angel?'

A Note on the Transcription

Every effort has been made to transcribe the original as faithfully as possible. This means that inconsistencies, errors in grammar, punctuation, and spelling, and even deletions, have all been reproduced. There are nevertheless occasions when a degree of interpretation has been required. Readers can judge for themselves whether in their view we have interpreted the original aright.

A Foreword.

I have much pleasure in bringing before the public this admirable little
work. To call it a gem is hardly to do it justice. It is indeed a threefold gem. It
scintillates as the brightest diamond, glows with life as the blood red ruby, and
is a very pearl in its simplicity and girl like naïvete.
To all those who have a real desire to understand the inner life of the woman
student, to all those who feel in need of mental refreshment, to all anxious
to know girl nature as it really is, I can confidently recommend the following
pages. Full of subtle humour, of delicate un-hurtful wit, of unaffected pathos,
abounding in passages of real intellectual depth & psychological value,
This work is by no means to be set aside lightly or read patronisingly as the
outpouring of two young minds. A true vein of earnest piety runs through the
whole diary and none but the most impudent of sceptical scoffers can fail to
be impressed by this earnestness of purpose.
To close this foreword without a word as to the really exquisite little sketches
which accompany each entry would be to deprive the work of half its value.
The execution of each one is perfect in its general intended impression &
its rigid adherence to realistic detail. Nevertheless unkindness & too much
personal realism are quite alien to the spirit of the artist; and great Praise &
no little wonder are due to her for the admirable skill with which she makes
each figure tell its own tale, while not one of her friends could justly rise in
the dignity of her insulted womanhood, and accuse the little pencil-wielder of
caricature or personal reference.
At the risk of appearing too infatuated with the genius of these two fellow
workers of mine, I feel constrained to end with 2 lines of poetry which I
cannot but feel are admirably appropriate:

> Two women were, of Humour and of Art profound
> On whom nor Wisdom, Wit nor Critic ever frowned.

<div align="right">

R.
St. Hugh's Hall
Oxford.
12th Nov. 1905.

</div>

Both down in time – No morning events.
Tea with the Dons – MKM with E.J. ⎱
 DMH " L.D ⎰
No Varsity news to record today – (unfortunately)
In the evening a Second Year Gathering took place in our room at 9.15.
GC Hough being joint hostess – The proceedings followed the well known
"Halloween" customs

 Bob Apple –
 Raisin digging –
 Cake cutting –
 Story stelling – Chestnut roasting.

The room was lit by two candles (borrowed.)
In the 'Bob Apple' honour is due to R.F who caused most amusement (in
fact could be heard in the other house) Mary Ottley cheated openly at raisin
digging, while Ludmilla carried off the ring from the cake in more senses than
one – GCH roasted the chestnuts with some success ~~which~~ and sat perilously
near their exploding skins –

Earlier in the evening glad news of DM's engagement arrived. The Diary
offers congratulations.

(Signed & adopted.) DMH – M.K.M.

Both down in time, though rather a scrape as far as MKM is concerned –
Sausages for breakfast.

<u>Varsity news.</u> 'Rat' seen in Corpus Quad by MKM. Great inquisitiveness
shown by the rest of the Hall anent Halloween Festivities. A quiet afternoon
with the Muses & varied by discussions & studies on physiognomy – MKM
thinks she has a weak face.
Scratch tea with R.F. Entertainment supplied by forced laughter, and
acrobatic feats.
Coaching for both ended in both being late for dinner – a scratch meal owing
to General Exodus to Classical Concert. Abbreviated prayers & no hymn also
in consequence –
Viva voce Examination in Hymn tunes conducted by DMH. MKM a dead
plough.
Evening ended by Sociable – Progressive Games –
Neither of the members of this Room obtained any distinction worth
recording, poor at peas, poor at pins, middling at tiddley winks, etc. MKM
rather low about not winning – DMH callous, tho' having got a red pencil for
consolation's sake –
It must be here recorded that it has rained <u>almost</u> incessantly today, but no
lives have been lost by drowning or swamping, fortunately. L.S. stated that in
the year 1903 there were six floods & that Hilary Term 1904 was a record for
dryness.

Signed & adopted. DMH . M.K.M.

Both down in time. M.K.M attempted work before breakfast —— An uninteresting meal.

<u>Varsity News.</u> H.M.P* seen by both, though on divers occasions. D.M.H. saw Prof. R. smoking pipe.

Another strenuous afternoon with the Muses. Tea at L.M.H. A deadly affair. Nothing to eat and nothing to talk about. Came away early out of sheer boredom. L.M.H has still some things to learn of S.H.H. 5–7.30. Worked hard, a fact worth recording. Dinner a notable affair as far as D.M.H concerned. Aspired to sitting at High having secured the promised support of M.K.M, but was basely deserted at the last moment. Without coaching from the H.T.S. this experiment must not be repeated. Silence reigned supreme. Oh! for the future foreign Politics, Home Politics, ~~and~~ Miscellaneous, Literature and Art (supplied by the Literary Supplement) and all those other aids to Rhetoric! We cannot help recording that this Thursday evening has been misspent. This Night of all Nights has been no Night for us! (No Union Tickets.) Both deeply stirred, however, by anticipatory invitation to Balliol Breakfast.

<div align="center">Signed & adopted M.K.M & DMH.</div>

[Note on illustration page] *"Such a curly headed lad"!

Both down in time. MKM <u>called</u> three times – rose at the third unwillingly, though just in time.

<u>Varsity News.</u> – D seen in Queens Lane, smiling.

Rat seen by MKM going to hockey – OFH also seen ploughing through the mud in slippers –

DMH played in the <u>most</u> unpleasant hockey match she ever experienced, in fact against a team of house-maids. Their name shall not be recorded – may they never reach posterity (nor may the score they made against us!)

MKM celebrated the afternoon by a visit to New Coll: personally conducted by Sue – This was the result of deplorable ignorance manifested at lunch anent Winchester. Sue dismissed in Long Wall Street while MKM hurried back to put the kettle on, and await in trembling anxiety the arrival of the food – General scramble, but in the end all in readiness for CJBS who came ten minutes late – Desperate pumping, with Excellent results. We know Varsity life better than we did. (Unfortunately ~~no~~ little news gleaned in the right direction!) The Earl being due at 5.30, CJBS, son of Sir J.S; KC, KCB, KCMG, was hastened unceremoniously off the premises at 5.25 – We can't mince matters at St. Hugh's.

DMH dined with RF at the small table. Some humour:–

 I planted a kiss, What came up? — Tu lips (two lips!!!)

 I planted father's scissors " " "? — Parsnips – (pa– !!!!)

DMH yawned over Metaphysics for half an hour, & looked intelligent. MKM spent the time otherwise.

 Acting Committee of Charades met in this room 9.30. MKM. DMH. M.I.O. GCH. RF. Impromptu Rehearsal. MIO appears as Lettuce, MKM magnificent as Herbert, while DMH & RF do the common as if born to it. Extracts from Mrs Green end a pleasant day.

<p style="text-align:center">Signed & adopted. DMH M.K.M.</p>

Both down in time – easy – D.M.H. had High breakfast. She shewed hopeless ignorance on Railway System of our country.

<u>Varsity News</u> Nothing to report although M.K.M went down to the town for the purpose.

D.M.H inspected Oxford Art at the Clarendon Hotel. She finds that her ideas on Art do not correspond with those of the Varsity.
M.K.M. manages tea well – gets two in, in the space of one hour.
Tremendous favourite with the S.S. Proud as Punch in consequence.
D.M.H. has "Chats with Charlie" in the apartment of R.F. Productive of some humour.
On her return is visited by Mrs. Balliol ushered in by the Lady of the House with great flourish. Mrs B. returns later to call on M.K.M. same ceremony – hopeless explanations.
Both attended Society for the Propagation of Cheap Repartee. M.K.M. leads the Opposition coached by D.M.H; the motion being "Man is given speech to disguise his thoughts" Style said to be Unionistie – what higher praise can man or woman seek?
An ugly woman, one of the ugliest is staying in the house. They say she is related to Sue. D.M.H. will have BICYCLE on the Brain for the third time this term. The shed will be at the disposal of any passing kleptomaniac.

<div align="center">Signed & adopted. MKM DMH</div>

Monday, November 6^{th.}

Both down in time – Margaret was up with the lark, no breakfast items.

<u>Varsity News.</u> The question is, <u>was</u> Hon. H.L seen by either, or both of us, (or neither) this morning? None will ever know, but each has her thought anent –

Shelley more than ever a blot on the landscape, though he thinks he improves the front of the Schools –

DMH with the help of RF left her mark forever on the Schools, in the form of a large ink stain in Room 8. The implements of the tragedy, ink & pink blotting paper (stolen from A.E.W) abandoned in the solitary wastes of the Park. There they tell their silent tale.

M^{rs.} M takes tea in our room, (buttered tea cake) and leaves two pots of jam, which we hope will help to kill off the Freshers. (metaphorically speaking.)

A very Don-ny Dinner. DMH L.D.
 MKM Sue + visitor, an archaeological specimen, who has travelled far & seen much. She looks like it, with weather beaten visage and flowing moustache. Resumé of Prof N's Lecture with additions by MC keep L.D's table alive.

Shakespeare Society interesting. The immortal Bill's character of Falstaff admirably interpreted by MIO, with careful omission of swear words – so good – MKM & D.M.H are not honoured by 'speaking' parts, but are told they are <u>very</u> important –

1st Meeting of the H.T.S – RF in the chair – Cakes & Ale. M.K.M opens proceedings with dissertation on Home Politics, comprehensive if not exhaustive, Athletics & Sport touched upon. M.K follows with awkward questions culled promiscuously from Whittaker for 1904. Little response, but much applause – hilarity hides ignorance – EAP delivers excellent address on Foreign Politics, in her best manners. Remarks confined to Russia & extremely well subdivided. DMH closes meeting with a few well chosen remarks on Literature & Art gleaned with much pain & tribulation from the Litt: Sup:

Bath and Bed –

Signed & adopted DMH. & M.K.M.

[149]

Both down in time. Easily accomplished despite cold. M.K.M breakfasted at High, not so D.M.H who grabbed a good place among the chosen.

<u>Varsity News.</u> M.K.M. saw H.M.P. but does not seem so elated as occasion deserves. Herbert quite humourous. D.M.H. has had no luck to-day. D.M.H was driven to the Muses in the shape of Miss D. who coaches at Somerville.
M.K.M. played the noble game of Hockey in her accustomed style & returns to tea with L.V. Has the supreme pleasure of meeting A.M.A.H T:R. viz – the Vampire of the A.E.W. The fell Tyrant of the classical students. The bully of all beginners. She is a woman (?) who has brutality but not wit, force but no humour, (she has a nose)

D.M.H has tea in Library – a Sunday School-treat meal.
M.K.M. dines at High, D.M.H again more at her ease among the chosen. We have before stated some reasons for avoiding the High.

D.M.H has a quiet evening with E.A.P. & the Muses. M.K.M attends the O.S.D.S. less dull than usual. Subject debated "That environment determines character." The Cartwheel all important and very smug. Let us ~~not~~ refrain from comparisons and contrasts between this and another Oxford Debating Society of even greater fame.
<u>Criticism</u> – A meal-y day!

<div align="center">Signed & adopted M.K.M. DMH.</div>

Wednesday. November 8^{th.}

Both down in time, though the closest affair we have had this term. DMH, with great self-denial, spends the time from 7.15 to 7.40 calling MKM almost incessantly, & is met by the cheery remark "I do like to hear you calling me". Ingratitude, thy name is woman!

<u>Varsity news.</u> Absolutely none.
DMH <u>did</u> hear a Lecture by "Prof: de Sel:" which wasn't bad, but what is such news as this among the possibilities of Varsity life?

DMH wins distinction at Beowulf Class for her remarkably happy rendering of the O.E. text, and for her bright answers in philology.
MKM attempted an afternoon with the Muses, but she did not find them attractive today. Far be it from us to hint that she usually finds them dull!
~~DMH~~ The Second Year 'pairs' practised this afternoon on the Cherwell. It must be recorded that the Second Year has now put a boat on the River, which if occasion requir~~inge~~s & with careful coxing should easily bump Somerville –

Two Freshers satisfactorily ticked off at tea. Humorous stories by G.CH. 'A spider, turned from its Ancient resting place under the pulpit cushion by the vehemence of the new preacher, wanders down the aisle in search of a home. Is met by another spider who says Join me in the Missionary Box – that's never disturbed."
No dinner items. DMH's double is here, but is more different than ever – Rehearsal of Charades. We have learnt a charming ditty.

"All the girls are loverly, overly
"All the girls are nice
"Whether they wear their hair in bangs
"Or over their dear little ears it hangs
"Whether they're twenty, thirty, forty, fifty or fifty three
"All the girls are loverly-overly
"–overly to me!

Signed & adopted DMH. & M.K.M.

Both down in time. M.K.M discussed Lord Mayor's show at high with little success.

<u>Varsity News.</u> We regret that again to-day all efforts have been in vain. There is still nothing out of the common to record.

Lunch and Hockey occupied till the 4^{th.} hour post meridian.
Two freshers more ticked off our account. We gave them good tea and good company – M.I.O was uninvited but welcome.
Spent the evening till after dinner in one continual worry anent charades. D.M.H & R.F. looked out trains for early departure while M.K.M. ate no dinner in a frenzy of stage fright which <u>even</u> affected her powers of speech. This is an unusual occurrence. Against our wildest hopes and expectations our tentative efforts were received with applause, nay real mirth. We really <u>were</u> rather good! M̶.̶K̶.̶ M^{r.} & M^{rs.} Dolphin were in one of their happiest moods. Miss Leeson was deep and sympathetic, while words fail us to describe M^{r.} Hallam's kind condescension & dis in the display of his genius. Veronica Perkins showed she was a real lady, quite one of the smart set, while nothing could raise Edie from the depths of commonness and plain unadulterated vulgarity.

<div align="right">Signed & adopted M.K.M & DMH.</div>

Both down in time. MKM again an early bird. We don't know if she saw the dawn, but we rather think not.

Varsity news. There is a beardless upstart arisen who poses as Hon. H.L., and has taken us both in! We will not however be baffled by such deception – nothing but the genuine article satisfies us. DMH has been basely insulted in company with her friend & confidant R.F. Before Napier begins, enter undergrad, ugly but funny, dragging in tow the veteran of the Schools, whom he commands to move the blackboard, so that he of all others can see more perfectly by this arrangement. DMH & RF are now deprived of all sight of the blackboard – Huge delight of undergrad, who giggles continuously during lecture. The "Bass by the window" returns from football looking hopelessly nice.

The only Event of the afternoon was Oxford Mission to Calcutta Service. G.M.S starts first from the Hall. She leaves at 3.20, on a bicycle the service being at 3.30 & in Keble Chapel (five minutes walk.) Such is clerical infatuation!

MKM has tea with M.B. She meets the daughter of the ~~Editor~~ Manager of the Times. Dull affair, though no offence meant – DMH takes tea with L.F.T. and is also honoured by meeting the great Miss H-S of histrionic fame –

No further Events till dinner, where MKM gleans some humorous anecdotes anent M^{r.} Dolphin –
The maid, aged 15, seeing his Evening clothes, remarks "First time I knew Master went out waiting!"
Again, when asked why she did not answer the door, replies "Master met me, and said `Don't bother Miss, I'll do it for you!"

 Ignoramae meeting at LMH. Sheridan's 'Rivals' read with some success & talent.
One of the best books on Henry VIII is by Pollard, Late Examiner. 'The Rivals' can be bought for 5^d if you only try long enough –

Signed & adopted DMH & M.K.M.

Both down in time. M.K.M. consulted the Muses for a very short space before breakfast. D.M.H. does not approve of early consultations.

<u>Varsity News</u> No morning items as neither went out to glean. Both went down town in afternoon with unsatisfactory results. New College Hall was graced this afternoon by the presence of D.M.H & M.K.M to hear about Assyrian Mission. The only object of interest was D^r Sp–R who however ejaculated no — isms! We were troubled by an awkward and quite uncalled for collection. It is perhaps gratuitous to mention that G.M.S was at the aforesaid meeting.

M.K.M returns to tea with some old friends D.W.S & R.W.G who were in their usual form.

D.M.H has inevitably Hall tea (bread & butter) with inevitable adjuncts.

M.P.P. & G.M.S.

No further news.

S.A. Sociable. Father Waggett.

R.F. has just returned from Rugby, a visit to the Miss Browns' Seminary where her sister is immured. We gather that she has made a favourable impression upon the erudite females. This is greatly to her credit, and she herself has said it!

Lamps flare if not attended to.

Pictures on S.H.H. walls never hang straight. ~~L.W.~~ The Lady of the House can be overruled by flattery. E.A.P. away for week-end.

<div align="right">Signed & adopted M.K.M. DMH.</div>

Both down in time. This morning saw the departure of a few of the numerous guests who have during this week made their presence felt among us. We now feel H.A.P.P.Y because we're F.R.EE –

<u>Varsity news.</u> We have had no <u>visual</u> luck today, but MKM has made a charming discovery. Out of sight & out of mind in the Library is a stack of delectable Oxford magazines containing records for several years back, of vital interest. Here we learn that Hon HL's maiden speech was a great success in Every way; "charming in delivery & fluent in language" he held the House spellbound & gave but a foretaste of the brilliant orator of the future. There were other charming little stories which Space will not permit us to record. Suffice it to say that they gave us infinite pleasure.

We regret to say that our sister RF has, during the week End, been on the sick list. However it gives us great pleasure that her indisposition was but a temporary derangement, & now she has returned to her usual bright little self.

We feel that one of those who have lately come into our midst has condemned herself with her own words, which are many & dull. Not only does she take upon herself to keep the conversation going, but she undertakes to make it unutterably boring & pointless. We feel we must inaugurate a School of Rhetoric for such as these, though DMH declines part in it, having none too much of the Easy gab herself. Shakespeare Society again shows off to advantage the histrionic talents of MIO. DMH & MKM have this night said their little say & retired to obscurity.

Signed & adopted. DMH & M.K.M.

Both down in time. Sausages for breakfast – we both agree that these sausages are the nicest we have ever tasted & think the fact worth recording. NB. change of Sausage from Wednesday to Tuesday – Last year they used to serve as compensation for the Litany.

<u>Varsity News.</u> DMH & RF see grey haired figure in MA gown padding down Queens Lane. RF exclaims "Too old for such haste!" DMH ~~with some~~ supplies age of MA and also name with alacrity. Scorned as an MKM in consequence – Shelley entered No 10 room <u>with</u> Prof: N. looking as though he had had a decided slap.
No lunch news, hockey as per usual –
Hall tea for both, with usual adjuncts.
MKM hied her to the High at dinner & did the pretty. DMH dined early in order to attend the Theatre, or rather S^{t.} George's Hall, which is at the same time the Young Man's Christian Association & Youth's Mutual resort. ~~The~~ The Home Students this night performed "She Stoops to Conquer" – They admitted none of the male sex, <u>except,</u> and this seems to us drawing rather a nice distinction, except those who have reached the supreme position of a <u>grandfather</u> – We sorrow to relate that out of a packed assembly, only three lone grandfathers could be mustered.
The performance was such as might have been expected ~~with~~ by those acquainted with the Home Students. Staging & costume Elementary. Sateen takes the place of flowered brocade, paniers are worn but unfortunately for appearance's sake are not padded; while the make-up was piteous! Poor M^{r.} Hardcastle's face savoured of the coal-box, while M^{r.} Marlowe & M^{r.} Hastings looked as though they would have been vastly improved by a good wash – M^{r.} Marlowe moved the house almost to tears by his impassioned, but somewhat belated speech "By Heaven, she weeps!". M^{rs.} Hardcastle was a head & shoulders taller than Tony, while Constance was common. Sir Christopher Marlowe was a fine figure.

Signed & adopted DMH & M.K.M.

Both down in time. D.M.H. consulted Muses for whole hour before breakfast.
This was caused by stern necessity in shape of A type's class.

<u>Varsity News.</u> For the first time in their lives D.M.H. & M.K.M. meet at
A.E.W. Interview affords DM.H much amusement, especially sight of L.S.
driven to performing in the A.E.W. He stands apart timid and retiring amid
the gay throngs of the other sex.
No lunch news.
At 2 o'clock M.K.M attends Committee meeting of the O.S.D-S. where she
plays the fool to the great annoyance of Treasurer – a serious and portly
woman who fears that the O.S.D.S. may descend into a mere 'rag'. We have
no hopes that this will be the case while she is an officer of the Society.
Both spend afternoon with Muses.
Tea in hall minus the usual adjuncts. Their absence has not been satisfactorily
explained. Was there indeed a Church workers tea or have the tasks of the
Churchwarden proved so arduous that they necessitate fasting?
Dons to dinner, though why we don't know. M.K.M is booked early in the
evening to fill up gaps in conversation at Sub-high. Her efforts were not
blessed with success Despite pink crêpe de chine. W.W. gives party –shews
off lantern slides of glaciers. Family evidently appreciative though their
remarks are sometimes irrelevant. Neddy an impossible child but grub good.
To-morrow is Thursday.

<div align="right">Signed and adopted M.K.M & .DMH</div>

Both down in time. It is perhaps gratuitous to record that MKM — but her
pride must be kept down.
A good dish at breakfast, eggs cut by the knife, or otherwise sardines & eggs
– we don't get this often enough –

<u>Varsity news.</u> DMH & RF decide, on close observation, back and front, that
Shelley, the Debauchee, & the BA are a disgrace to the Varsity, and rank
as mere black sheep. The 'Varsity' discusses whether Oxford men are ill-
mannered? We refrain from any unkind remarks on the subject.

Hockey for DMH, Muses for MKM, or rather, MKM muses and DMH is
amused when she muses thereon – (laugh here) A pleasant scratch tea, MKM,
DMH & GCH; three penn'orth of halfpenny buns & a robin roll.
DMH has been invited to Concert at New Schools to go with Cobbs.
An awful rumour reached us that there was no Chaperon handy, and therefore
no Union for us. Now we had tickets, and we wanted to go. However, EJ
arrives with welcome news that we may dare "unchaperoned to gaze*" upon
the members of the School for British statesmen – With feverish anxiety
MKM & DMH scan the faces of ex-officers but in vain. "Fate went ever
thus"¤. The Debate lost much of its point in consequence. If the Speakers
of tonight are England's Embryo statesmen, the prospects of the country are
indeed small. We feel we must refer to the Magdalen gentleman who spoke
fourth. His politics were fanciful & savoured of the nursery, his style Easy
& boyish not to say infantile. He offered the country some good advice, &
assured an incredulous & smiling House that his remarks were quite true.

*Hammonds Ode to OC.
¤Beowulf

Signed & adopted DMH & M.K.M.
Smudged by DMH. an accident.

Both down in time. Only eggs for breakfast and those of a type we do not recommend.

<u>Varsity News.</u> Shelley again enters lecture in deep conversation with Prof. N. We don't admire Prof. N's taste. M.K.M saw a figure on horseback which she thought she recognised. Need we say more. One of those who has lately come into our midst has a made a fatal mistake, but nevertheless one that has proved a snare to others. She asked an <u>Undergraduate</u> for a Statutes Book 1905 thinking he was an assistant. The undergraduate treats the demand with cold disdain but his companions find the affair productive of humour.

D.M.H played the pianner with Louisa.
M.K.M read in Camera.
D.M.H asked by S.S. to help hand bread and butter to M^{rs.} C. Rather a 'typic' but quite amusing. An improvement on her daughter.
M.K.M. had tea ~~L~~ in the high society to which she has become ~~lad~~ lately accustomed, the visitors being dons. N.B. Her hostess afterwards remarked that M.K.M. was very useful in the talking line. Far be it from us to suggest that she has any other use. The 'Ignoramae' study the 'Ballad' and find it rather a suggestive form of poetry.

<div align="right">Signed and adopted MKM &</div>

Both down in time – No breakfast news though both took it in high quarters. Kedgeree (?) for breakfast – Bony, stringy, oniony & hot!

<u>Varsity news.</u> Saturday never supplies us with any titbits in this direction.

This is the coldest morning we have spent as yet. Driven from our room by the depth of the temperature, driven from the Common room by Kenney, we resorted to the Drawing, so called! There we find a gibbering company, shivering round a fire which is being encouraged by a newspaper! MKM & DMH try to defy the elements by hustling together on the bed (sofa so called) wrapt in sundry blankets – we did not get warm, neither did we get through any work.

Match against Etceras. Hall beaten 5–1. A good match all the same.

Recherché scratch Tea – DMH, MKM & MC – the latter enlivens proceedings by various racy anecdotes. Here is a sample. Simple aristocrat spends Friday night at Cowley – not being accustomed to fasts, he feels keenly the pangs of hunger. Is greatly relieved when Brother murmurs outside his door "Dominus tecum", to which he replies "Thanks very much, put it down outside." A good story we think.

MC & DMH repair to OE chat – MC succeeds in hiding her ignorance, & MK displays her knowledge. DMH & RF are strangely silent – "A type" takes it for complete comprehension and is fearfully bucked.

Sharp Practice discusses Co-Education with passion and eloquence (?) MKM & DMH both display their rhetorical powers.

<div align="right">Signed & adopted DMH . & M.K.M.</div>

Both down in time. Sue not at breakfast. Cold ham toast.

Varsity News. MKM has the great pleasure of seeing Shelley, as grievous a blot as ever, adorning the front steps of the Schools – DMH & RF sweep past the aforesaid little hog like Duchesses, careful to lift their skirts out of Contamination – MKM, however, asserts that Shelley has all her sympathy and is by no means as black as he is painted. Prof Nap caught almost swearing. Enter the little Shrimp of the Schools, and seizes duster, whereupon Prof N. ejaculates with some force "Damp it!" Great discussion in the class as to what he said.

No lunch news. G.C.H plays in United match – the Diary offers congratulations. DMH & MKM Muse for an hour, then Scratch tea with G.C.H.
No dinner news with MKM – Shakespeare Society deplorably dull – H.T.S proved successful as before, though three of its most prominent members were absent. MKM in consequence took charge of Home Politics – and Miscellaneous which she rattled force extempory to the awe & wonder of the audience.
 "And still they gazed, and still the wonder grew
 "How one small head could carry all she knew."
DMH with GCH takes dinners with Cobbs, and goes to Musical Union Concert. A very enjoyable time. She sees there her new acquaintances of yesterday, who are related to friends in Chichester. Driven home in state. Forgot to mention that met old friend D^r W. who examined DMH in piano forte playing at the age of 13. Not recognized, however strange it may seem.

 Signed & adopted DMH. & M.K.M.

Both down in time. M.K.M. was called early, but heeded not the summons. M.K.M. suffered grievous blow at Breakfast — no sausages.

<u>Varsity News.</u> This is indeed a day of days M.K.M has actually seen Face to Face the Pride of all the Beauchamps. This is the first time he has been seen accidentally and in the flesh – Thus the need of capital letters. Shelley is learning manners. We notice with gratification that he removes his pipe from his cherub mouth as D.M.H. & R.F. pass. M.K.M.'s opinion somewhat justified.

Some lunch news. The Hall congratulates itself on retaining English Essay prize in hands of M.A.K.
D.M.H has tea with R.F after an interesting coaching. M.K.M & G.C.H go to tea with M^{rs.} Massey. Maynard from Oriel gives dissertation on golf, M.K.M & G.C.H not well up in subject, but "pretend they know a lot." Agnitah calls. Neither of us greatly bucked. Both of us again impressed with essential differences between male & female debating capacities and gifts of oratory. We are also convinced of advisability of preparing a speech.
D.M.H attends victorious cocoa party. She whistles "See the Conquering Hero come" accompanied on tea cup for the benefit of the company.

<div align="right">Signed & adopted M.K.M & DMH</div>

Both down in time. Sausages for breakfast at last! MKM for sheer gladness of heart has two.

<u>Varsity news.</u> MKM saw the Rat in the distance, but only gazed reproachfully at one who is so bad a correspondant. We regret deeply that this the most important item in the page should be so meagre today. It is our misfortune rather than our fault.

No lunch news.

DMH went on the river for half an hour & came back & joined MKM in consultation with the Muses – MKM leaves her arduous duties to get ready tea party which she & MIO are giving to LS. Function a great success, though RF & G.C.H who take upon themselves the duties of critic & reporter (outside the door) Express their disgust anent the opening ceremony. LS obviously bucked & proffers tentatively a general invitation for some day in the dim future.

MKM calls on Lettuce, but Edie announces that she is engaged –

Dinner. DMH begins by playing the footman so gets very behind in the meat, & has to put up with cold vegetables; M.K.M sits at LD's table which is entertained by the unfailing wit and vivacity of EAP. It is decided that the King "in private life" does not look a gentleman – Also this postulate: – every "Bertie" is an ugly man, but not every ugly man is a Bertie.

DMH attends Sociable, & dances like mad. Feels a different <u>woman</u> in consequence. MKM asserts that no difference is yet apparent. She hopes manifestation of the conversion is still forthcoming.

<div align="center">Signed & adopted DMH. & M.K.M.</div>

Neither down in time. D.M.H is awakened out of a deep sleep by the sound of the coal box being planked down and her astonished eyes open to see the leery Stephens close the door. This horrible spectacle has haunted her all day, so that she has not been her usual bright self. The Lady of the House tells us that M^r. Stephens was equally upset "He is so very particular to knock at the door". We know of another side of M^{r.} Stephens –.

<u>Varsity News.</u> M.K.M meets a Bertie who comes under the category mentioned yesterday.
No Lunch News. Both play in a most miserable game of Hockey. D.M.H. deplores her public spirit & gratuitous self denial which prevented her going to the Irish Plays.
Scratch tea with Molly. GUMs discussed & denounced.
D.M.H. attends Slade Lecture on Rembrandt. M.K.M. goes to the Union. The curly headed lad opens debate "That this House would regret the identification of the Conservative Party with M^{r.} Chamberlain's fiscal proposals" The Pride of all the Beauchamps replies with much force & abundant wit. The ugly Librarian speaks third and an oddity from Christ Church fourth. The missing link or L^{d.} Hugh Cecil the last speaker on paper suggests that the hon^{ble} opposer can still afford to learn wisdom.

Signed & adopted M.K.M & DMH

Both down in time –

<u>Varsity News.</u> MKM has nothing to record.

DMH on her return from Prof. N. at 1 o'clock, had the supreme pleasure of seeing the "Earwig" eating his lunch, or rather we should say drinking – one touch of nature makes the whole world kin –

No lunch news.

DMH has a lively single with the hockey captain of S^{t.} Hilda's at the Central club. She has scratch tea with Gertrude, and goes like everyone else to the P.O.P's Lecture on Aspects of Modern Poetry. Prof B.has in everyone's opinion excelled all former triumphs – The only dissenting voice is Ahmah's – she thinks he spoke too philosophically and not poetically enough – She would –

Some humours at the Lecture, seeing that all Oxford was there. MKM sits in such a position that she could see Prof de Sel, AL, Bishop Mitchinson, Canon Bigge, Prof Bradley, Higgs of Balliol, Prof- Caird, and other unknown Big-Wigs, to say nothing of <u>all</u> the <u>other</u> members of the University – Prof de Sel's two Undergraduate Companions watch him narrowly, and take their cue by his expression – so are the great imitated! At the end of the Lecture HMP is addressed by female, half his size, who asks if he attended the Irish Plays – HMP swelling with remembrance of speeches before the mighty airily replies "Er, no rather occupied yesterday!"

Ignoramae – ready to come but loth to go.

<div align="right">Signed & adopted DMH & M.K.M.</div>

Both down in time. Both driven to High at Breakfast. Sue not in a conversational mood.

<u>Varsity News.</u> No news of any description owing to fact that Saturday morning is spent exclusively with the Muses. No lectures so no humour; No Queen's lane and so no oddities.

No Lunch News.

D.M.H. has the proud position as centre forward in the St. Hugh's match versus Somerville. She manages very well despite the enormous difficulties of playing against the ex. captain of the United. The chief feature of the match figured among the spectators. A gigantic male form made his appearance on the field and shouted lustily for St. Hugh's. Somerville evidently thought this bad taste, but St. Hugh's was greatly bucked. Tea with E.A.P. where we parted with our scalps. D.M.H quotes Charles Fox in the process. D.M.H goes to Senior Common Room Party – Some excellent Music and abundant humour. From fear of rivalling the bumptiousness of the Oxford Magazine we refrain from criticism of any kind. We only remark that St. Hugh's has taken a new motto "If it weren't for the Plough

 The fat ox would go slow."

 (Sussex Song)

Signed & adopted M.K.M & DMH.

Both down in time. Interesting breakfast in high quarters. MKM 'found' indulging in some of her raciest Parliamentary terms and political epithets thus early in the day and week. We forgot to mention that we both rose betimes and served the Muses.

<u>Varsity Intelligence.</u> DMH today is the lucky dog. She saw our honourable friend crossing the High with perky air, & perky stick, & perky cap. We wonder whether such aggressive perkiness is a symbol of success at the poll, but this is only a conjecture.
Now for Shelley – The little hog "has his Exits & his Entrances", but today he certainly had his Exit, for he left Prof. N's Lecture ~~with~~ crowned with a mortar-board, looking <u>too</u> patchful for words as per picture. Varsity news seems to have accumulated today. MKM sees "the-only-man-in-Balliol-worth-knowing" (she may not be so exclusive tomorrow) approach M^r. A. to ask intelligent question with an important smile & charming air. However, a girl armed likewise reaches M^r A first, whereupon the aforementioned only-m.i.B.w.k turns on his heel, & stalks down the Hall, baffled & disgusted.

A distinctly humorous, but very enjoyable tea. RF entertains friend from Eastbourne, & we are hired out as conversationalists. Such is our success that we are voted "charming girls" – We are both distinctly typical throughout, but eat a good tea from excellent provender. M.IO returns to our room where we all three discuss theatrical complications loudly denouncing & ridiculing the V.P. Small measured tones from L von V's room convulse us with horror. The V.P. has such excellent ears! MKM bravely investigates the room, & all are reassured the danger is nil. MIO & DMH have not felt the same women since but MKM abominably callous.

<div align="right">Signed & adopted DMH & M.K.M.</div>

DMH attends our morning diurnal devotions – MKM far too busy, what
with going Balliol Breakfast – We feel that this great event must occupy some
space in the Diary. First as to MKM – She sits beside a man who can only talk
politics – This "Seeley" points out is very great luck, for MKM, she says, can
talk on nothing else – (MKM is very bucked at the criticism). The man was on
the whole satisfactory, safe for one blemish in his judgment – He considers the
Hon HL "prosy in parts" though he kindly adds that he is witty sometimes.
These young Balliol men must be taught a thing or two. And now we come to
"Miriam's Conquest". MH we feel has met her Fate –
 She is overheard remarking to her Companion "I don't
know what I should have done without you", and seems altogether smitten –
We shall watch the sequel with interest, for Dixon was his name o!

Varsity news. Rather a scene at Prof N's lecture. between RF and DMH
versus undergraduates, anent position of Blackboard. MKM feels she need
not add any more Varsity tit-bits after her Balliol experiences –
DMH teas with P de BBC
MKM with the Fish – no humour –

An exciting dramatic meeting with the V.P. Absurd suggestions, & hopeless
plans – nothing settled and everything proposed from English drama &
fiction – MIO in accordance with expectations discusses the feasibility of
performing John Inglesant in Lorna Doone – "O for a muse of fire that would
ascend the highest heaven of invention" as Bill would say –

 Signed & adopted DMH & M.K.M.

Both down in time. Bacon for breakfast, badly cooked. M.K.M. sits in the seat of the mighty, the V.P. being at the High. It is gratuitous to say that she filled her place with grace and majesty.

Varsity Intelligence. None. Just our luck.
No lunch News.
Both spend afternoon with the Muses till advent of G.N-S. who babbles like the brook that goes on for ever.
Tea with G.C.H. to meet Miss B.H. This a great success. E.A.P. surpassed herself, while M.K.M. & D.M.H aired their French witticisms. We cannot help thinking of Monsieur Beaucaire who would assuredly have sent his thanks up to Heaven with ours that we were not born Frenchmen ——
M.K.M. remarks that Small amount of bread and butter merely means that it is an hors d'oeuvre, seized with sudden misgiving she changes it to chef d'oeuvre to intense delight of assembly. D.M.H improves occasion by remarking that a witty friend of hers translated hors d'oeuvre by "war horse" The company are politely amused until hors de combat is suggested as giving more point to the story. In spite of these little failures the "feast of reason and the flow of soul" were a perfect treat. We all ate too much but thoroughly enjoyed ourselves. D.M.H is given a ticket to hear M^r McInnis sing; she is very enthusiastic on her return.

Signed & adopted M.K.M & DMH.

Both down in time – DMH drew matters rather fine by only waking at 10 minutes to eight. However with a rush and a bustle we were down in time – Worried eggs for breakfast. MKM finding the V.P's seat occupied assumes today the rôle of SS at breakfast. (Grace and majesty as before – see yesterday)

<u>Varsity News.</u> No morning items. Evening story recorded below.

Hussy episode – scene Queens Lane – Dramatis Personae. DMH. RF. <u>and</u> Hussey –
Time – 1 o'clock p.m.

DMH & RF see hussy approaching on side walk, and both mentally resolve not to be ousted from her position on the pavement – Result – standstill of RF & Hussy against the wall – We consider this to be the height of chitness, more especially as R.F had to give way –

Hockey match against LMH II. We won 5–0. Huge chortlings – This is recorded as an historical event that later generations may know that <u>now</u> we play LMH Ist.

N.B. It is since the advent of DMH & GCH that the team has been so successful, though there is no pride in this whatsoever. MKM attends uproarious "hockey" Hall Tea, where she facetiously nick names Peggy the 6^{th.} Forward –

DMH takes tea with M.C & cheers the Higher Local victims in their unhappy lot.

We must not forget to mention that this morning MKM purchased surreptitiously (breathe it low) THe VARSITY!! This really respectable weekly will find in us constant ~~con~~ patrons, that is if our means will rise to it – (It costs 1^{d.})

And now we come to the Union – DMH went – The motion is of no interest, neither are the speakers, but one of the Ex-officers, and, we grieve to say, defeated candidate for the Presidency, was altogether charming. <u>He</u> came, <u>solely</u> for the purpose of clapping the result of the Polling, and the name of the President Elect – more of the latter anon. Junior Treasurer refuses to take steps in some matter.

Our honourable friend – What? not even a pas seul?

J.T. no sir, pas du tout. And this is called «depressing" wit!

<div align="right">Signed & adopted DMH . M.K.M.</div>

Both down in time. M.K.M., D.M.H. & E.A.P. have semi-political meeting after Prayers. This makes them late for breakfast and they find literally nothing to eat.

Varsity News. M.K.M. cut lecture and consequently she has no news to record. But D.M.H. has astounding luck the Pride of all the Beauchamps again crossed her path, looking, she is sorry to say, horsey and common but nevertheless charming (see picture).

Quite a humorous occurrence at close of Prof. N's lecture. Ungraduates thinking it time to go home to lunch try all the Varsity tricks to shew Prof N. their opinions. Their efforts were efficacious but impolite. — Huge tappings of feet, two change places with great bustlings, while back row led by Shelley laugh and talk gaily in strident tones.

D.M.H. and RF return via town in order to avoid Hussey in Queen's lane. We own this is cowardly but perhaps advisable. Peace at any price! To quote the great.

Afternoon spent revising and completing the back pages of this historic work. In spite of large "Engaged" on door we feel qualms every time a footstep passes the door.

A pleasant quartette take tea at O.C. Lv.V. D.M.H. G.C.H & M.K.M. Lv.V. pays the shot, we eat the grub & "dare unchaperoned to gaze" and also find some humour in the band, especially the double bass.

Hasty Opposition meeting summoned by E.A. Philips Esq: M.P. (Member for Paddington) M. Ottley Esq elected leader. Last Ignoramae meeting under presidency of M.K.M. L.F.T. gains prize for "Miscellaneous guessing".

<div align="right">Signed & adopted M.K.M &</div>

Saturday Dec 2nd

Saturday Dec 2nd

Both down in time. Breakfast conversation entirely turns on the first
session of S^t Hugh's Parliament to be held in the evening.

<u>Varsity News.</u> D.M.H has no luck although she visits the "West End" of this
university city for the purpose of attending a lecture. M.K.M. is warned by
a telegram to avoid her lecture at Queen's. She does so with a pleasure which
is not complimentary to the Lecturer.
No Lunch News.
D.M.H. spends the afternoon in a becoming fashion with congenial friends at
the Piano. M.K.M. broods over her coming speeches & wishes she had never
come to S.H.H.

Both take tea with M^{rs.} M. Owing to the short notice the grub is not up to
the usual, but an engaging black kitten provides magnificent entertainment
and makes up for any omissions in the food ~~time~~ line.

The last meeting of the H.T.S. for Michaelmas term takes place in R.F.'s
room. M.I.O is allowed to attend & choses a seat conveniently near the
chocolate biscuits, M.K.M. however insists on her vacating this place as she
too is fond of the aforesaid biscuits.

<u>St Hugh's Parliament.</u> The Speaker took the chair at 9.45. The Labour
member for Battersea (otherwise our beloved D.M.H) asked a difficult
question of the member who had undertaken the Presidency of the Board
of Education, in such a way that the House was led to think that the labour
member is no imitation. The reply of the minister for Education was not
conspicuous for its lucidity. Other questions of less importance were
answered by the members of the government with varying success. The
Aliens Bill was introduced by the Home Secretary and passed its second
reading despite the able speech of the member for South Paddington.

<div align="center">Signed & adopted M.K.M.</div>

Both down in time – A regular Parliamentary meeting after breakfast to discuss last night's proceeding. General amusement at the Minister of Education.

<u>Varsity News</u> – The Scholar shows his ~~figure~~[?] Vicar round Colleges, at least so MKM surmises when she meets him in Merton Chapel in company with a parson. Huge deference and opening of doors on the part of the parson, patronising condescension on the part of the scholar (who is good looking –)

Lunch news – D.M.H. again assumes the rôle of VP, MKM plays second fiddle in the SS's seat – Poor lunch – Ugly meat and no puddings. Called away in middle for Hall meeting to decide on wedding present for "Annie the Co-educated" who is marrying an amorous chauffeur.

DMH goes to reading of Paracelsus by D^r Pope at the abode of Margaret Lucy Lee. The reading satisfactory, in fact thrilling and D^r Pope knew Browning, but hostess and tea Eminently deplorable – MLL breaks into a soliloquy on the part of D^r P with "I am sure D^r Pope we are all much obliged to you, and now you must all come and have some tea" in her brightest tones. "o woman! in thy hours of ease" – etc.
M.K.M has tea with F de BP BC – Provender good, company poor.

OSDS Great Debate of the Term. MKM makes her maiden speech. A great success – DMH applauds as "lygonistically" as possible, both hand and foot – The Hon Prof. advocates coeducation as a matrimonial bargain – She would – MKM & MIO are elected as Treasurer & Secretary for next term – The Diary offers congratulations – Fate goes ever as it will.

<div align="center">Signed & adopted DMH. & M.K.M.</div>

Both down in time. Sausages, though not good ones, for breakfast. So are our fondest hopes most often blighted.

<u>Varsity News.</u> D.M.H sees her musical friend. (For portrait see Nov:20th). She also sees Hon H. This is becoming such a daily occurrence that there would be no need to record it but for the fact that he was observed to be smoking a cigar. N.B. He smokes "Mark that".
'Prof. de Sel' horribly put out by finding corner of page torn off. Great delight of men at lack of words.

D.M.H spends a large part of the afternoon with the Muses more especially the (un)palatable umlauts. M.K.M. only spends short part of the afternoon employed thus.

A very humorous year tea party & one of the nicest we have had. The room was arranged as for the a Christmas party by R.F. Only crackers and holly were needed to complete the analogy. At the risk of their reputation D.M.H & MKM & RF take off other members of the Hall. Their audience is delighted, but they themselves feel nervous as to the sequel. D.M.H. takes the final plunge with the "A type" and comes out with clean hands "if a little bit knocked about".
M.K.M. gives tea to her colonial friend from Magdalen & learns that it is not the thing to do well in 1st term collections. We quite agree with him.

<div align="center">Signed & adopted M.K.M. &</div>

Both down in time. Breakfast exceedingly dull – MKM sits at high. Sue is still away, and the VP is not a conversationalist in any form of the word – DMH collects bike excise.

<u>Varsity News</u> Close of Herbert's last lecture marked by an oration – The great man blushes to the roots of his hair and the joy of the girl students.

Lunch disturbed by Hall meeting – DMH gets <u>no</u> pudding. SHH is feeling somewhat slighted by an impertinent proposal that it should play for a challenge cup with S^t Hildas. Hockey match between No.28 & No.17. No.17 wins by one goal. Nice scratch tea DMH, MKM, GCH, RF, in fact, the Junior Common Room.

Evening amusements – MKM dines with M^{r.} Armstrong in company with MIO, & RAL. Gleans a great deal of University intelligence of varying interest. She would! Among other items we learn that the Scholar's name is St....s, a name already used in the Diary in a different spirit, and with more or less unpleasant associations (See Nov. 23^{rd.}) Also that L^{d.} B....p was sent down, and that our noble friend, the joy of Magdalen, is a half-brother; etc.etc ad lib –
DMH goes to <u>most</u> patchful Smoking Concert at S^{t.} John's. It doesn't sound very respectable but the V.P cast a cloak of propriety over 'the proceedings' or rather over our presence there. DMH meets her old friend Charles, who tries to renew his Christian name acquaintance, and also sings – We are advised to go at the end of the first part of the programme because you never know <u>how</u> rowdy they may get in the 2nd part, but we were given a foretaste of what was to come by a Comic, not to say Music hall Song, illustrated by a fandango, and accompanied by some excellent whistling. The VP is as pleased as punch, & roars with laughter. DMH fancies she hasn't caught the words – Walked home in very amateurish manner in the wet.

<div align="center">Signed & adopted DMH. & M.K.M.</div>

HILARY TERM 1906

Both down in time. Very poor time at breakfast! Worried eggs, and those cold. <u>Varsity news.</u> We have not as yet sampled the 'High'.

After deep consideration we find there is <u>no</u> news today, so will proceed to supply instead some tit-bits from yesterday.

DMH accompanied by GCH & MAK wends her way home from Cathedral after the shades of night have fallen. As they turn into Norham Gardens they are startled by a sudden "chink", and proceed to search the ground for some yards round for any lost treasure. In spite of the faint guiding beams of a gas lamp their efforts are fruitless. They therefore give up the struggle and pass on. Hardly have they proceeded five paces before another strange chink resounds behind them. This time they are not to be baffled, though in the dark. They are almost on hands & knees, grubbing in the mud, when they hear a masculine voice behind saying "Can we help you. Have you lost something?" While a second ditto exclaims, lighting the pavement by his cigar, "oh, there's a sovereign on the path. I saw it distinctly". Great excitement & searching for matches. The moment a match is lit each party looks at the other, three girls v. three men. The "Sovereign" proves a halfpenny but the incident was distinctly an amusing one!

SUMMER TERM 1906

Notes for week ending April 28th 1906. Written on Ap. 26th

DMH & MKM find it necessary to state that owing to a startling development in application for work they are unable to keep this Diary more than once a week – They offer their condolences to you, fair Reader, for all that you hereby miss –

The 1st Event of importance this week was the inaugural Tour of the H.T.S. to the famous hamlet of Littlemore, which demanded our inspection for three reasons. ① . The President's Father received his first glimpse of knowledge there. ② The Uncle of our noble friend and colleague M.C was Rector there. ③ It is generally supposed that Cardinal Newman had something to do with the place. The walk was enriched by constant change of companions, every possible combination of the six members being tried with much success. Moreover we saw – (a) Shelley (tracked to his lair!) (b) University tennis. (c) An accident (d) A view. (e) a child sucking a broken china cup. etc.etc. We concluded our Tour, the 1st. we hope, of many, in the President's room where we partook of a 10d. tea – We are appalled by a threat from our noble President to double daily any contribution not paid before Sunday.

<u>Tuesday</u> uneventful –
<u>Wednesday</u> Year Tea party. First part without incident, but when tea had warmed the cockles of our hearts we entered on our anecdotage – Many were the Tales told both profane & vulgar but they pleased us as only questionable jokes ever can. We present the palms of victory ~~of~~ to MIO & MC., two promising "raconteuses"! Honourable mention to GWW, our genial hostess, for her "Divers" story.
<u>Thursday.</u>
An uneventful day till night drew nigh and we hied us to the Union, on the 1st ~~night~~ Debate under Presidency of one whose name is not unknown to a Reader of these pages. MKM takes careful note of how a President should behave, – look, speak and sit – She is highly satisfied with the model of tonight. A splendid Debate on the Education Bill, especially from an episcopal point of view – House crowded top & bottom, but by dint of much chivying and many hints to the uninitiated we get a good seat after all.

<u>Friday</u>

D.M.H. and M.K.M. attend lecture in the High School on Oxford Portraits
in the eighteenth century. It was not the fact they were egged on to do so by
Potter, or encouraged by Jourdain, or even that the pictures being eighteenth
century might be useful that made them thus eager to attend (of course not). It
was because the lecturer was one Dr Woods father of a famous son renowned
for Politics & Mountaineering. No resemblance can be traced between father
and & or between M.H.W. & the Angel Gabriel. At all events we are now au
fait with the family.

Signed & adopted. DMH. & M.K.M.

Notes for week ending May 5th Written on May 2nd

Monday

The 2nd tour of the H.T.S. covered fewer miles & evoked less interest –
we went to the Museum. Each member did her best to find an object of
interest in the whole show. Architectural beauty nil, historical importance
scanty, literary & artistic value non est, the spot does not fill the
regulations of the Society – Having been there sometime, our patience
fizzled out & we returned home to tea with M.C. our retired but still
interested member.

Tuesday

A memorable day on many points. D.M.H. & R.F. have their first
coachings with the Pixie. The nature of R.F.'s coaching may be judged
by the fact that she has converted the pet name of Pixie into that of the
Beast. DMH. is relegated with her client Dryden to the Kingdom of fools.
Both R.F. & D.M.H feel in a somewhat headless condition having had
this part of the anatomy bitten off by A.J.C. In this severely damaged state
they proceed with nearly all the Hall to a churchman's protest against
the Education Bill in the Town Hall. The speeches of the Bishop of
Oxford, Sir William Anson and Lord Hugh Cecil were approved by the
Junior Common Room & the President of the Union whose presence was
conspicuous by its shirt front. On the vote of condemnation being put
to the ~~motion~~ meeting one futile dissentient voice was heard to complain
"Down with them". Nobody knew what, but that didn't matter.

<div align="right">Jersey-pere.</div>

Saturday

Sharp practice – P.BC a good President. Motion "that a democracy
without an Aristocracy is a bane to any country" debated quite warmly
but without logical reference to the subject. MK. makes her maiden speech
with perfect sang-froid, though without charm in delivery ~~or~~ and manner,
or wit and reason in matter.

Notes for week ending May 12$^{\underline{th}}$ Written on May 10$^{\underline{th}}$

Sunday – Killed off so-called Gardiner – + MPP & LFT.

Tuesday – HTS migrates to S$^{t.}$ Peter's in the East and Christ Church Cathedral. Baffled in attempts to explore the crypt, but very interested in architecture carefully indicated by MKM who surreptitiously consulted Alden's Guide behind every pillar. We took in her tarradiddles about Christ Church like lambs, for she was the acknowledged guide – Pleased with invitation from M$^{rs.}$ M to view the "boats" next week.

Wednesday. Tea with M$^{rs.}$ M. Clinched the bargain anent – "boats" – DMH has mighty struggle with WW for tennis championship & proves victorious in the end.
Dinner. During this meal Sue casts a bombshell among us — St Hugh's is going to give a party on June 9th to all & some in Oxford – We may all ask visitors with the exception of other 'shes'. But the whole point of the announcement is this – the programme is to consist of music & dancing. We shudder to think of the flurry, skurry, hurry & worry undergone by all till the show is safely past, especially in the case of Sue, Nellie & Lena. Most of Hall attend Sociable, including W.H. a new arrival, whose lengthy toilette of an hour and a half did not produce a worthy result – Plain, prim, and pink.

Thursday DMH trots off to Balliol breakfast with Ludmilla. Has a distinctly thin time herself but watches Ludmilla holding a small levée of admiring undergrads with some amusement. Sat by Professor Wentley, head of University for men & women in Toronto. M$^{r.}$ Dehn (see portrait on Nov.16$^{\underline{th.}}$) inspected closely – M$^{rs.}$ C a very humorous old woman. MKM visits her pet Thursday resort at 8 precisely, in the neighbourhood of St Michael Street. Some amusement evoked by artistic efforts of Librarian & Junior Treasurer to draw the President. Hon H, awfully bucked, insists on signing the portraits.

Notes for week beginning May 12th Written on May 14th

<u>Saturday.</u> A frivolous day on the whole. MKM begins Early by going to
breakfast at Queens. Gratuitous to mention that May & Rhona were
late but MKM paces the quad with the Senior Bursar of Queen's & is
quite in her element – DMH spends afternoon on the River with two of
our revered old members. Being a "glorious" afternoon they got to the
"Rarepitts", and were in consequence rather late home for <u>the</u> Event
of the day, viz. an "undergraduate tea" in the garden of "the House".
The hostesses L.v.V. & GWW were charming, the former swathed like
an Indian priestess in a white Liberty gauze scarf. The men were five in
number, the girls seven, and all went merry as a marriage bell. They stayed
till nearly six thirty and then departed most reluctant – we have all agreed
it shall not be the last of this type of entertainment.
The R.O.M (see above) honoured our room at 9.30 – After partaking of
tea & biscuits the party which was a large one resorted to Y<u>e</u> anciente
gayme of "Dumb Cramboe". In the attempts to find a word to rhyme with
Teak*, R.F posed as the little vile Blot (see Nov. 21st) & should mentioned
as really successful (no offence) meant can be took!). Free & easy use made
of Ludmilla's <u>very</u> best 'Eights' hats, while 2 pokers and Molly's evening
wrapper completed the stage properties – Party apparently appreciated by
all, except those who listened from the other House (markedly W.H)

<u>Sunday</u> DMH & GCH make most successful call on Cobb, & reap the
invitation they went out to glean –

<div align="right">P.To</div>

*'Freak'

<u>Monday</u> – This was the day we slogged.

<u>Tuesday</u> A "derned dull day" till evening hours drew nigh, then MKM with
much dignity, DMH's belt & GCH's gold chain assumes the rôle of
President of the O.S.D.S. (This was not the complete costume of course)
Animated discussion on the Education Bill; the Vampire brought down
the House.

<u>Wednesday</u> – DMH spends an uneasy morning, weighed down by the
tormenting terrors of the Tennis tea, and the trying task of choosing
champion's ties. We grieve to say that LMH has become even more
mumpy than before, and are to be treated accordingly, being allowed the
run of the garden, but not admittance to the house. We grieve to say that
Somerville worsted us, we being nettled by the net play of the jumping
Jackson, ~~the~~ the hard hits of the terrible Terry. However S^t. Hugh's
defeated the first pair of the Oxford six, in spite of the fact that it plays
once a week with the Varsity Champions. DMH forms one of a party of six
friends to attend the theatre. Supper off poached eggs at 6.45, scuttled out
of the front door with stealth at 7., reached theatre at 7.15, got in early door
by paying your extra sixpence, saw Martin Harvey it is true, but never a
sign of a chaperon – The Breed of the Treshams an admirable play.

<u>Thursday.</u> MKM Balliol-breakfasts, and chooses her subject for conversation
as before. See Nov.28^th

<u>Friday.</u> We attend the conferring of honorary degree on 5 heathen Chinese.
The Vice Chancellor makes one or two Latin blurs; while one Chinee
utterly refuses to shake hands with the V.C. to the intense delight of
the Varsity in the top gallery & ~~when~~ he at last submits to take the
outstretched paw.
In the afternoon we go with M^rs. Maes & Hugh to the Boats.

The event of the afternoon for us, was not whether Univ was bumped or whether Magdalen rowed over but that we had tea at the Union & what's more had it in the debating Hall. We ask you, fair Reader, to imagine us examining the pictures & sampling the President's chair – It was the last place in which to have tea, but we enjoyed ourselves.　We learn from Hugh that the proper name for Christ Church is "the place just opposite the Post Office". Such is fame.

<u>Saturday</u> Dorothy went to Eights & kept her eyes open.

<u>Monday</u> Dorothy sickened for mumps (which have not developed yet.)

<u>Tuesday</u> Dorothy went to first part of Eights & owing to the Pixie's carelessness missed the second part.

<u>Wednesday.</u> A thrilling not to say frivolious day. Having carefully culled Miss Simpson as a chaperon we proceed to the Boats in a carriage escorted by C.T.B.S. (for parentage see　　). We procure front-seats on Magdalen Barge and are introduced to a Rhodes Scholar, the first of the species we have met. We dispel any lingering qualms that he has had about swimming across & in the end have the pleasure of seeing him perform this feat without drowning. A patchful afternoon interrupted though not marred by the rain. Besides the two bumping races we have the pleasure of seeing Magdalen's aquatic sports.

The cox we grieve to say was treated disrepectfully. Smart & elated with victory he emerges from the Barge only to seized on either side & thrust into the water. Joke fully appreciated by all but the cox – His blazer ruined. Keble Concert concludes Eights week festivities. Great success, all but the Exit.

The joy of this very humorous day much damped by the knowledge that our sister Rosalind is again indisposed, this time German Measles has her in its clutches. The fell disease has also laid Rhona Lane low. The whole Hall lies in fear of swelling the German Band.

MICHAELMAS TERM 1906

Oct 13th was our Opening Day. It found us still in the same room & same clothes – DMH greets MKM at the beginning of her last strenuous year with the cheery remark "I've done all my work." It seemed a pity that time & money was to be wasted on a 3rd year. Far from this being the case with MKM, we are at liberty to state that these revered walls will contain her for yet another year more. Dreams of fourth year bossiness overwhelm us – Sue Nellie & Lena just the same after 3½ months parting from us –

> "Time cannot alter them nor custom stale
> "Their infinite variety"

<div align="right">as the Poet hath it –</div>

Despite alarming rumours to the contrary we found the Lady of the House still wields (with Sue) her temporal sway. New stair carpets –

Freshers

1st & foremost we have among us a Russian Princess who by her uproarious loquacity & bursting sense of humour already rules the household. She has already immortalised the homely mortarboard by terming it a "quadrangle", and shocked the Varsity by reference to its members as "boys" in loud & familiar tones – Her appearance is taut, and her chief vice unpunctuality –

② An untitled Jap of mouselike propensities and uncertain age. Her evening national dress is a source of great interest to the Hall –

③ A Pre Raphaelite model of good brains & shy manners – Yet to be understood, but infinite possibilities –

④ A penny bun – (A High School girl of the worst type.) whose currants are just appearing

This little bun & the PRM bracketed together make a nice pair.

⑤ A well meaning student of the English School – Too young & toothy – ~~Tolerable~~ Inoffensive but dull.

⑥ Co-partner of the above – At present an unknown quantity.

⑦ Two women who can only just be tolerated at present. Time, perhaps, will reveal their better qualities – We will say no more.

⑧ Uriah Heap – a myth.

<u>November 9th</u>

As there is little to record we think it advisable to mention now & here who are new coaches are and what they are like. Dorothy's must be dealt with first for he is the famous Prof de Sel already mentioned unfamiliarly in these pages. (see Nov. 8^{th.} 1905) Now we are able to speak of him on first hand knowledge and will implicitly state (1) That he is not an ogre as some have falsely led us to believe.

(2) That he is as like Napoleon as ever & to this D.M.H can testify, she having gone into the matter thoroughly.

(3) That he has shown considerable discernment in that he has asked DM.H & M.AK. to dinner whereas former renowned pupils have had to be content with tea or at most lunch. Of the dinner anon.

M.K.M's coach is less interesting both from the point of view of physiognomy and renown. Suffice it to say that he is young, blue eyed & long haired and is chiefly remarkable for his affection for Plato. Our advice to him would be to dwell upon the recommendation contained in the title of Haydn's famous song "My mother bids me bind my hair".

November 16th. 06

Nov: 16th MK & DMH attend dinner at Prof de Sel's – Four undergrads
to two girls – a good proportion! Prof de Sel & his wife charming,
dinner good, conversation ripping – MK honoured by intercourse
with the great during dinner, DMH afterwards. The latter treated as an
artist, fearfully bucked in consequence.

<div align="center">A HUGE SUCCESS!</div>

A few hours after the above event this landing of Nº 28 awakened from
sweet & dreamless slumber by a catastrophe. First of all the sound
of loud babblings are heard without by MKM, who leaps out of bed
at once & rushes to the scene of action. DMH shaking off the bonds
of sleep – but slowly hears sounds of an excited Princess and sharp
commands on the part of MKM to "bring a sponge" - DMH is filled
with dreary imaginings that someone is hurt, but is relieved by MKM's
entrance to say that the Princess's room is on fire!

MKM it appears has been very on-the-spot and has taken all management of affairs into her own hands, dashing through suffocating fumes at the risk of life itself to open the window – DMH later on enters (having spent some time vaguely searching for a dressing gown) to ~~view~~ find a really amusing scene both from a comic & psychological point of view.

Lena & her sister are both there, scared as kittens, with their hair in plaits & in nightgowns – Being just useless. Ludmilla, pale & calm, with blue robe swathed majestically, ~~with~~ wearing the air of an aristocrat awaiting a revolution. The Princess, wrapt in a blanket, babbling, giggling, joking, talking incessantly, finding the whole affair one large ~~joke~~ gibe. Finally MKM, the personification of "fush", directing operations with a "Bring more water ha!" sort of air. DMH a spectator, "who kept her eyes open."

 To this enter

 1st The Lady of the House & the Satellite – the former clothed in a magnificent red dressing gown. We feel that the opportunity for displaying such a treasure was one in a hundred. Satellite in morning dress. "What 'as bin 'appenin 'ere'" are the tragic words of her ladyships opening speech, & we feel that the situation is at last realized when she ejaculates "Ridiklus!"

 2nd. Mamma – tall, gaunt in a coat &

skirt, entering rather like the Ghost in Hamlet – stoked and pressed out by daughters.

The conflagration appears to have been started by the Princess chucking her bolster from the bed in a momentary fit of ire, & it falling just in front of a fiery furnace such as would have amazed Nebuchadnezzar himself.

The smell was, at the time, the foulest on record, and has hardly yet departed –

Nov: 24th

Nov: 17$^{th.}$ At a party at Mansfield M.K.M. hears the following story ——
Siamese prince at Balliol succeeds in passing "Smalls". He cables home as follows – "Rejoice with me for I have passed "Smalls" His delighted parent cables in reply — "we do rejoice, fourteen noble youths have been sacrificed". A propos of the same story, M.KM learns that a man at Hertford has been rewarded by his father with a motor car for passing the same difficult examination – The Varsity is trying to solve the problem as to his scale of rewards for Mods & Finals.

Nov: 22$^{nd.}$ In Company with a few of the chosen
DMH & MK.M repair to M.AK's 21st birthday fête. The Study transmogrified for this occasion only. While guests partaking of ~~absolutely~~ burnt cocoa an absolutely uncalled, for though kindly received, entertainment is supplied by DMH & RF.

This is followed by an authorised variety programme in which the performers were practically chosen by lottery – E.AP. led off with a comic song O'Flanagan's band accompanied feelingly by DMH on the table. G.C.H followed with a Highland fling skillfully performed over the fire irons & still continued, as if on her native heath, long after the fire irons had been kicked away. Molly & Rhona with a distinct shirking from responsibility executed an unorthodox & material cake walk. A recitation furtively rendered by D.M.H. Soul stirring scene from the Gipsy's last curse by two other members. (Stage properties an overturned chair & a hockey stick.) & an impersonation by MIO completed an excellent programme.

The company next proceeded to Dumb Crambo – Some of the best remembered items are ——

1. Play scene from Hamlet. Smile – Audience of ~~that~~ DMH's cast of features meant for Hamlet.

2. Adam & Eve & the Serpent Guile — LFT Eve to the life.

But we also numbered among our repertoire Trial Scene Merchant of Venice, Cromwell's dismissal of Parliament & the Egyptian Promenade (Nile.)

Atalanta is a good sort at heart but somewhat spoilt by an unfortunate manner! ~~She~~ In appearance she is of medium height with dark hair always well dressed. Her complexion is sallow her eyes dark, her eyebrows wear the inquiring expression that betokens a search after further knowledge. The worst thing about Atalanta is her bursting speech ~~wh~~ over which she seems to have no control and which seems to suggest a hot and haughty temperament. She is characterised by great application to anything she lays her hand to, especially work over which she grinds by day and night. She appreciates a good story, and has a distinct sense of humour but does not as yet show signs of being very witty in herself.

Lucy has little to attract the casual acquaintance and less to interest those who fate has thrown more often across her path. This does not prevent her from being a worthy person especially in her own estimation and does not detract from her goodness of heart ~~wh- causes her to take pity on those unfortunate beings who are not often~~ This last mentioned virtue causes her to take pity on those unfortunate persons who had had little access to her person and to spare them some precious moments ~~of~~ in which to enjoy her company alone. Lucy is profuse in her hospitality and a great authority on etiquette, a gentle reprover of the erring and an unfailing encourager of the weak. Her conversational powers are not ~~exhau~~ extensive, but she is not a bad listener and knows well how to ~~hold her tongue and be silent.~~ Smile appreciatively and hold her tongue.
Her figure is fat and ungainly, but she is quite good at games and if it weren't she thought herself better than she is in this direction her achievement would be more universally approved.
 She is a gossip.

Nausicaa is a maid whose great aim is to appear the leader of her clan. She is both small and uncomely. She wears her hair in varying fashions, each worse than the last, her choice of hats, especially tamoshanters is not good, neither does she walk with an elegant gait. Her scholastic attainments are not to be despised, but she takes good care that you shall never forget it, by her patronising and easy manners. Be it here remarked that though an intelligent woman she has not the gift of good reading, and reduces to a state of exasperation her unfortunate listeners. She makes it her mission to draw out any latent virtue in her shyer acquaintances. Her voice is grating and

whining and she wears a constant smile – ~~and~~ She is ever engaged in pushing into the conversations of others, while her powers of debating or shall we say argument are only waiting to be developed.